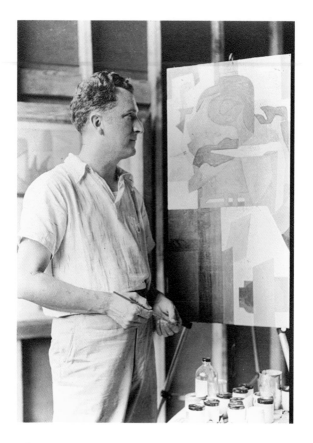

Dedicated to Jane Anne Wickiser

RALPH L. WICKISER

The Covered Apple Tree 1987-1998

and

Shadows on the Grass 1996-1998

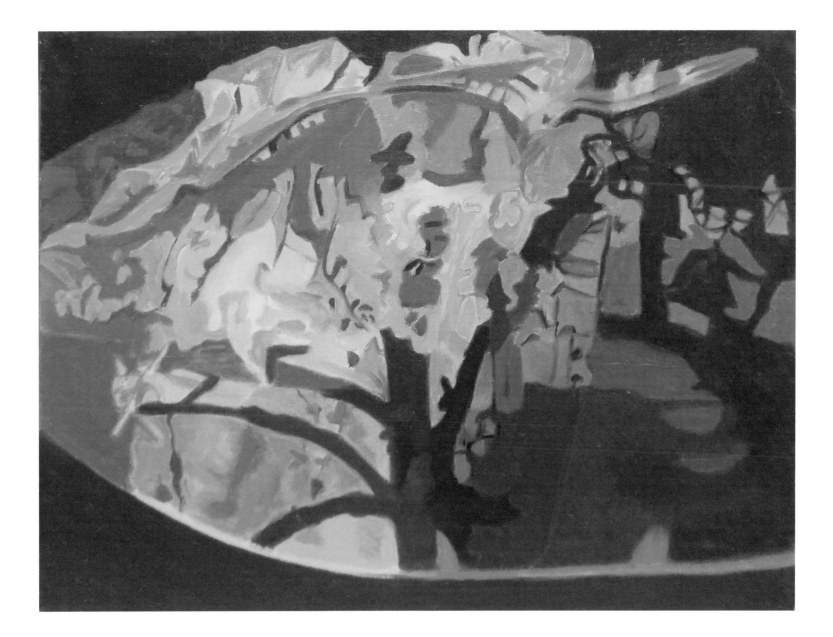

RALPH L. WICKISER

THE COVERED APPLE TREE 1987-1998
AND
SHADOWS ON THE GRASS 1996-1998

LYDIA WICKISER TORTORA

WALTER WICKISER

WALTER WICKISER GALLERY, INC., PUBLISHER

Editor: Walter Wickiser

Designers: Misa Hoshino, Angela H. Kang

Library of Congress Control Number: 2013902199
ISBN — 978-0-615-76064-3

WALTER WICKISER GALLERY, INC.
210 Eleventh Avenue, Suite 303
New York, NY 10001
www.walterwickisergallery.com
wwickiserg@aol.com

COVER IMAGE: **FLURRIES**, 1996, OIL ON LINEN. 36" X 50"

PAGE 2: **TREE HALF COVERED**, 1991, OIL ON LINEN, 12" X 16"

CONTENTS

Photograph of Covered Apple Tree taken by Ralph L. Wickiser, Woodstock, NY, 1990

INTRODUCTION

Few of the late 20th century artists have escaped the snitch-driven critics' propensity to assimilate and categorize artists' works. Wickiser did. Not by accident or design, but rather by the sheer force and mastery of the many dynamic phases of his life-long works of art. Abstract Expressionist, Analytical Abstraction, Abstract Representative, Figurative Painting, Semi-Figurative: terms all valid and true at some point in the 70-year span of Wickiser's paintings. But how do you categorize Wickiser's paintings, or the poetic soul and unshared visions that surpass the depths of mind-constrained contemporary words? You don't. It is sheer Wickiser!

A renowned author and art educator, Wickiser's painting career is a visual odyssey that began in the 1930s with works exploring both figurative and abstraction, then turned to pure Abstract Expressionism in the 1950s, Abstract-Representation in the 1970s, only to expand the scope of his works in the 1980s, producing a plethora of jewels in the *Reflected Stream* series, which he continued to redefine and paint until his death in 1998.

At the age of 78, retired from all distractions and living in the much-beloved hillside house he and Jane had built 40 years earlier, Wickiser would embark on his final journey into works of his immediate and cherished environ: the land, trees, earth, grassy knolls and trodden path to his studio and beyond. *The Covered Apple Tree and Shadows on the Grass* is a collection of brilliantly executed paintings, gem-like sonatas that sparkle and resonate with the magnitude and force that was Wickiser.

His radiant and lyrical images portray the kindred spirit Wickiser shared with nature, it's endless beauty, joy and sorrow, sounds, touch and senses. He was fascinated with the changing light patterns and shapes of the apple tree. Nurtured from seedling to fruit-bearing harvest, he covered the tree with cheesecloth to deter birds from stealing its fruit. Veiled in cheesecloth, limbs bowed heavy with fruit, shadows flickering on the ground below, Wickiser again and again transformed the canvas into motion-charged forms and colors that intoxicate the viewer.

In the magnificent *Beige Net* (1988), summer's hot, bullish splash of colors dazzles the viewer. Shades of reds, beige and ochre's collide and merge in abstract forms. Reflected leaves and limbs, barely recognizable, floating, stretching, grace the canvas to create a symphonic masterpiece of mind and palette. In *Covered Tree II* (1992), one is immediately struck by the stark modulation of contrasting colors and intricate shapes that first draw the viewer into its core, then shift the eye outward to be reabsorbed by its total infinite beauty and intrigue.

Flurries (1996), is a triumphant eclogue of poetry and motion. Reflected light and shadows peer through the apple tree's draped canopy to reveal its leaves and branches, twisting, rising upward, in syncopated dance, above the ground's earthen tones below to delight and entice the beholder.

An expert photographer, Wickiser used the lens to capture his subject matter, its varied light patterns, colors and shapes during different times of the day and seasons. But it was his acute mind's-eye that took palette in hand and transformed nature's treasures into the magical splendor and enchanting drama of his works. He loved poetry, classical music, the land and its environ. The studio was his sanctuary, where embryos of paintings took birth, often to the music of magnificent classics such as Beethoven and Mozart.

At times almost mystical, *Purple Net* (1994-96) is one of Wickiser's most poetic works of art. The luminous colors emit a brilliant glow in perfect harmony with images that float and shimmer in prismatic rapture. Here, the artist's unspoken words are born naked in resounding effigy, shared only by the beholder.

In the final years before his death in 1998, Wickiser returned to a more refined, halcyon and simplified canvas. The colors are less translucent, more subdued. Shapes and forms yield to a more abstract motif. In the breathtaking *Shadows on the Grass* (1997), light and shadow cast somber hues of green and umber patches on the grassy earth. Whether by design or subconscious thought, two of Wickiser's last works: *Purple Stripe* (1998) and *The Winding Stripe* (1998) are haunting images of the path to his studio. For nearly five decades, Wickiser had traversed the worn-trodden path, stopping momentarily to gaze at the mist rising over the valley, mountains, reflected light and shadows of natural forms that stirred him, or to tend to his beloved fruit trees and blueberry bushes.

The natural beauty of the paintings created by Wickiser in *The Covered Apple Tree and Shadows on the Grass* embodies both the mysteries of the physical world and depths of inner mind and spirit. The simplicity of their appeal and timeless potency will remain a living force to move freely, as on an axis, in this generation, and generations to come of all that can be achieved in modern art.

Lydia Wickiser Tortora

February 2013

Lydia Tortora is a freelance writer whose works have been published in numerous publications including *The New York Times*. She is Ralph L. Wickiser's daughter.

Opposite: Ralph L. Wickiser painting in plein air, ca. 1934

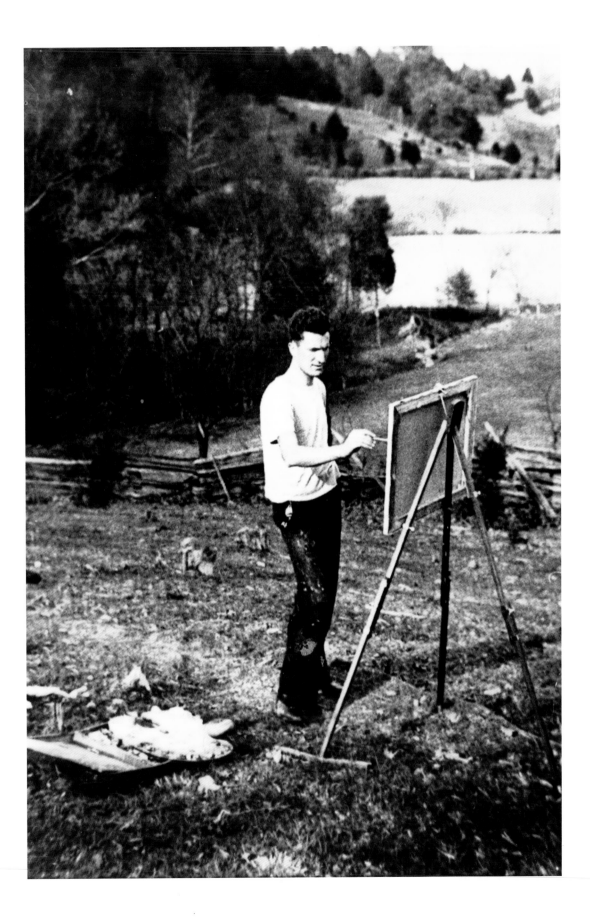

ILLUSTRATIVE HISTORY

BY WALTER WICKISER

Ralph Lewanda Wickiser was born in Greenup, Illinois in 1910 to Hirk and Lydia Wickiser. His family consisted of three brothers and four sisters. His middle name, Lewanda, was an Indian name. Ralph's grandparents were farmers and his father worked two jobs seven days a week. During the evening, his father worked for the Illinois Central Railroad as a telegraph operator and in the day he did painting and wallpapering. When he wasn't attending school, Ralph helped his dad and often spent his summers tending his grandfather's apple trees. In his younger years, Ralph was also a musician and sang at church-related events, such as weddings and funerals, with his friend the famous folk singer, Burl Ives. During his college years, he played guitar in a dance band. But, from a very early age, Ralph wanted to be an artist. The earliest known paintings are watercolors from his second grade class, which exhibited extraordinary talent at a very young age. His teachers praised and encouraged his artwork.

When Ralph was 18, he left Greenup to study at the Art Institute of Chicago, where he learned life drawing from 1928 to 1931. During the Depression, however, he could no longer support himself in Chicago and had to return to Greenup. At his mother's suggestion, he attended the state teachers' college at Eastern Illinois University in Charleston. There, he studied art, despite his frustration with the lack of modern art education at the time in America. During these years, a famous Brown County artist, Paul Turner Sargent (1880-1946) took Ralph under his wing and taught him a great deal about painting. Ralph would often accompany him to paint outdoors. He graduated with a BA in arts in 1934, and went to New York to visit Columbia University. At a friend's urging, while in New York, he went to see Hobart Nichols, director of the Tiffany Foundation which gave grants to artists through their Artist-in-Residency program at its compound in Oyster Bay, Long Island, New

York. The application process to the program was lengthy, and Ralph hesitated to apply. Instead, with a couple of paintings under his arms, he went to see Mr. Nichols. Mr. Nichols was so impressed that he said, "Wickiser, I'm going to do something I've never done before and give you an immediate Artist-in-Residency with the Tiffany Foundation this summer." That summer he lived and painted in Oyster Bay. An exhibit at the well-known Grand Central Art Galleries followed in April 1934, where one of his paintings was reproduced and reviewed in *ARTnews*. This became a turning point in Ralph's life.

Earliest known work by Ralph L. Wickiser: Watercolor from second grade, ca. 1917

Mr. Nichols wanted to send Ralph to Europe to cultivate him as a painter internationally. At the same time, the president of Eastern Illinois University contacted Ralph that he had arranged a teaching fellowship at Vanderbilt and Peabody in Nashville, Tennessee where Ralph could work on his master's degree and eventually his doctorate. Because the president had been working on obtaining the fellowship for Ralph for quite a long time, Ralph felt obligated to accept the offer.

Tiffany Artists Are Now on View At Grand Central

The Louis Comfort Tiffany Foundation presents the work of the artists who have been its guests during the past season at the Grand Central Art Galleries, 15 Vanderbilt Avenue, New York City, until November 3.

Many artists have been the guests of the Tiffany Foundation including Cathal O'Toole who was awarded the Joseph Pulitzer Traveling Scholarship of $1500, which is annually awarded to a student at the National Academy of Design, for 1934. Edmund R. Amateis, 1921 Prix de Rome winner of sculpture; Monty Lewis, awarded the Guggenheim Foundation Scholarship, Luigi J. Lucioni, Joseph Margulies, Lawrence T. Stevens, Frank Schwarz, Anna Fisher and many others.

Mr. Hobart Nichols, N. A., who is the Director of the Foundation, is very pleased with the results of this year's work and invites all those interested in the younger American artist to visit the exhibition.

Ralph Rowntree's pastels are known from being shown in his exhibition at the Macbeth Galleries a season or so ago. Among the water colors, Dean Faussett, Jared French and Lloyd Goff are represented with characteristic examples. Cathal O'Toole is here again, as are also J. B. Watrous, Theodore P. Shoudy, Prescott M. Jones, Carl Buck, Frederick Peterson, Horace Day and others, among them those who are new to gallery-goers as well as old friends.

The two paintings from this exhibition which we reproduce in this issue, are typical of the differences in temperament and technique to be found among the artist's of the Foundation. Ralph Wickiser's marine subject, illustrated above is severly restrained in upon the expert rendering of the still mood and pattern. Cathal O'Toole's life elements, carefully grouped "Conglomerate" on page 13 concentrates accentuate their values.

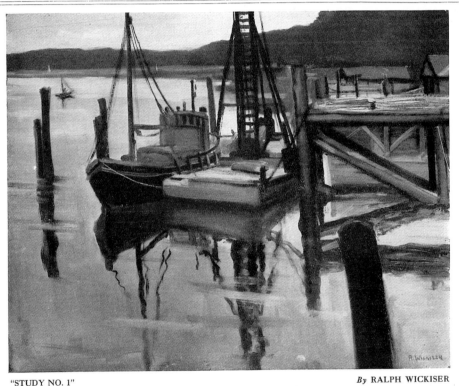

"STUDY NO. 1" *By* RALPH WICKISER

This painting is included in the annual exhibition by artists of the Louis Comfort Tiffany Foundation now on view at the Grand Central Art Galleries.

Study No.1 reproduced in *ARTnews*, October 27, 1934

In 1936, Ralph married Jane Anne Bisson whom he met while attending Eastern Illinois University. Three children followed: Eric in 1942, Lydia in 1945, and Walter in 1952. He continued to exhibit his paintings and that year his work was shown at Rockefeller Center in New York. In the fall of 1936, he took a position teaching art at Louisiana State University (LSU) in Baton Rouge while simultaneously working on his PhD in philosophy at Vanderbilt and Peabody. While at Vanderbilt, he remained a very active painter and exhibitor. In 1937, he exhibited at the Studio Club in Nashville, Tennessee. From 1937-1941, his work traveled to museums throughout the country in an exhibition "A New Southern Group". The High Museum in Atlanta, Georgia, bought one of his works for inclusion in its permanent collection. In 1938 he received his PhD in philosophy of education and aesthetics from Peabody College. The following year he had a solo show at the Grecian Gallery in New Orleans, Louisiana. Since the early 1930s, Wickiser's style of painting swayed back and forth between abstraction and representation.

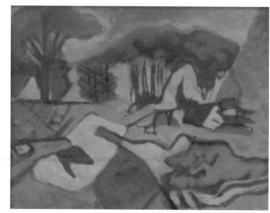

Over The Hill, ca. 1934, Oil on board, 8" x 10"

In the summer of 1939, Wickiser made his first trip to Woodstock, New York to study color lithography with Emil Ganso. There he found a kindred spirit in the Catskill mountains, their vast spacious beauty surrounding the small, vibrant artists colony that was then Woodstock. It was the beginning of Ralph and Jane's annual summer pilgrimages to Woodstock. For the first time, the young painter was exposed to contemporary art movements and to pioneer Abstract Expressionists including Franz Kline and Barnett Newman. An immediate camaraderie developed between Wickiser and Yasuo Kuniyoshi, who hosted a big party for the artist and Jane to introduce them to his Woodstock friends. This led to long friendships with Arnold Blanch, Paul Burlin, Rollin Crampton, Doris Lee, Eddie Millman, Milton Avery, Philip Guston, and Barnett Newman. Wickiser later invited Burlin and Kuniyoshi to LSU to lecture to the art students. Wickiser became very good friends with the painter Rollin Crampton, who was particularly close friends with Barnett Newman, and the two spent long hours together talking about art. Eddie Millman and Barnett Newman would often come over to Wickiser's Woodstock home and have discussions on painting. Wickiser warmly referred to Newman as "Barney".

Mexican Series, ca. 1940, Watercolor on paper, 14" x 8". Reflecting street life in Guadalajara and Tosco, when Ralph and Jane visited Diego Rivera

In the summer of 1940, Ralph and Jane drove from Louisiana to Guadalajara and Tosco in Mexico, where they spent time with Diego Rivera. As Jane recalls, "He was so ugly he was beautiful." The summer yielded a series of watercolors created outdoors in the marketplaces of Guadalajara and Tosco. In 1941 he was named Chairman of the Art Department at Louisiana State University in Baton Rouge.

During the war years, Wickiser enlisted as a commissioned officer in the Navy and was stationed in Washington, D.C. In 1942 his work was shown at the Corcoran Gallery in Washington D.C, the San Francisco Museum, and the Oakland Museum in California. The Degaldo Museum in New Orleans, presently the New Orleans Museum of Art, gave him a solo show in 1943. An exhibition of his work followed in 1944 at the Dayton Museum in Ohio, and in 1946 his work was shown at the Associated American Artist Gallery in New York. He continued to alternate between abstraction, figures, landscapes, and combinations thereof always to push the boundaries of his imagination.

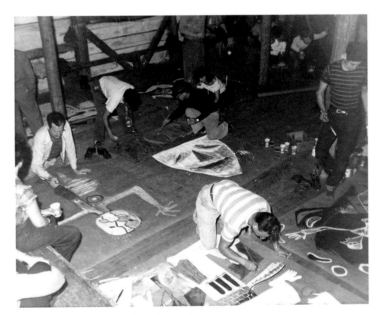

Preparing for Maverick party
Wickiser painting, far left, Yasuo Kuniyoshi, middle with hat

Courtesy of the Woodstock Artists Association & MuseumArchives (above and right)

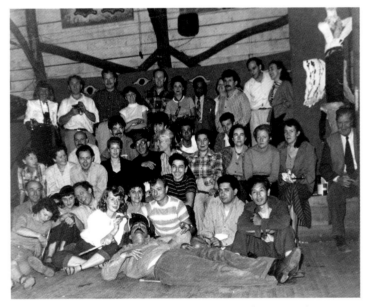

Group party at the Maverick (Wickiser, top row, third from left)
Other notables in the photo —
Philip Guston and Herman Cherry (top row second and third from right)
Yasuo Kuniyoshi (in the middle with hat), and Edward Millman (second row, third from left)

In 1946, he became a contributing editor to the *Encyclopedia of the Arts*. As a creative painter, art educator, and writer, Wickiser was keenly sensitive to the lack of good textbooks on teaching art. His first book, *An Introduction to Art Activities* was published by Henry Holt and Co. in 1947. The book became one of the most widely used textbooks for teachers and students of art education in colleges and universities for decades. Wickiser also coauthored *Mardi Gras Day* in 1947 with Caroline Durieux and John McCrady, two other well-known Louisiana artists. Many of his lithographs, published in the book, were inspired by photographs he had taken of Mardi Gras. It was at this point that he developed a serious interest in photography to enhance his range as an artist. That year his work was shown at the Dallas Museum in Texas, and ten of his color lithographs were reproduced in an article *The American Highway* in *The Lamp*, published by *Standard Oil* of New Jersey. In 1948-49, he was commissioned by Ford Motor Company for a watercolor series, which were reproduced in their magazine, *The Ford Times*. In 1948 his work was exhibited at the Library of Congress at the Annual Print Exhibition.

Wickiser working on lithographs

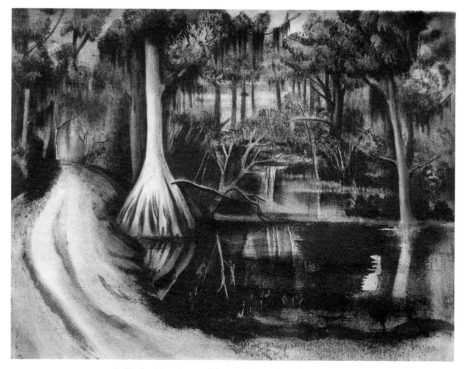

In The Louisiana Bayous, lithograph reproduced in *The Lamp*

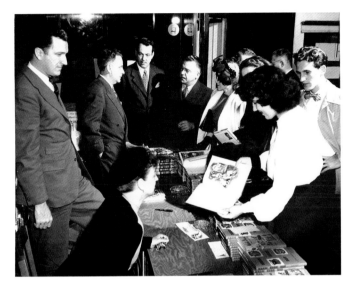

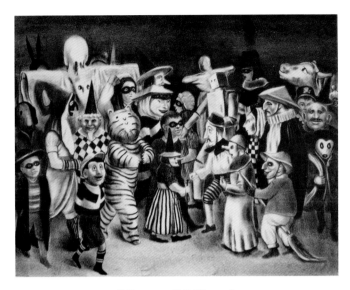

Mardi Gras Day Book Signing Event
Wickiser (far left), well-known Louisiana artists, Caroline Durieux, and John McCrady

Halloween, ca. 1948, lithograph

Ralph and Jane continued to summer intermittingly in Woodstock until 1949, when they bought land there and built a house and a studio. In 1950, Wickiser hosted a conference at the Woodstock Artists Association with talks by Franz Kline, Robert Motherwell, and Yasuo Kuniyoshi. In 1951, Wickiser hosted the Fourth Annual Conference on Art at the Woodstock Artists Association with Herman Cherry, Franz Kline, Yasuo Kuniyoshi, Robert Motherwell, Barnett Newman and Ben Shawn.

Kuniyoshi worked with Wickiser on the conferences and helped organize them. In 1950, his work was shown at the Metropolitan Museum of Art in New York, and at the Pennsylvania Academy in 1951. In 1952, he had a solo show at the University of Louisville in Kentucky.

Third Woodstock Art Conference, "The Artist and the Museum", September 1st and 2nd, 1950 (Wickiser, far right) The speakers were: Philip Evergood, Lloyd Goodrich, Edith Halpert, Rene d'Harnoncourt, Hartlett H. Hayes, Jr., Yasuo Kuniyoshi, Andrew Ritchie, Francis Henry Taylor, and Hudson D. Walker.

Courtesy of the Woodstock Artists Association & MuseumArchives

From 1950 through 1968, the focus of Wickiser's paintings was non-objective. The series of paintings created were *Compassion I* (1950-1958), and *Compassion II* (1959-1968). Some of the work was inspired by Matthais Grunewald's *Isenheim Altarpiece*, which he viewed as one of the greatest artworks ever made. In the *Compassion I* paintings, he wanted to create a visual feeling of uplifting or resurrection through the use of square-shaped panels throughout the paintings and glazes.

Wickiser's work was included in the 1953 Annual Exhibition of Contemporary American Painting at the Whitney Museum with such artists as Milton Avery, Ralston Crawford, Willem de Kooning, Adolph Gottlieb, Philip Guston, Georgia O'Keeffe, and Jackson Pollock. In 1954, his work was exhibited at the Cincinnati Museum. He continued to exhibit at the Woodstock Artists Association and his lithographs were in a State Department traveling exhibition in Europe from 1954-1956.

Ralph Wickiser's abstract paintings from the 1950s are exemplary of that period of modernist American art; yet they also look astonishingly fresh. His great love of both materials and the act of painting is evident in the meticulously considered treatment of his surfaces, in their textures, in the balance, range and subtle modulation of colors—the elegant blues, reds shading to rose, greens, yellows, the orange burnished gold—and in many layers of glazes that give his colors their intensity and resonance, their depths. His handling of the paint alternates between thin, translucent passages which the light can penetrate and rich, heavy impasto; in some instances, the paint has been fashioned into rosette-like shapes, and abstract flowering into bas-relief. He also affixes nails, paint tubes and other painting paraphernalia to the surfaces as if to include all aspects for painting within itself. Surface, space, color, light, brushwork are all subjects, as are the grid and the band which are the dominant structuring devices though more evident in some paintings than in others. Yet despite this phenomenological approach, the surface seems to dissolve into illusion, shimmering at the edges like a mirage. Some of these canvases were inspired by Grunewald's Isenheim Altarpiece, whose mysterious, difficult colors and sharply expressive figures in the extraordinary central panel echo the sorrow and pity of the crucifixion with particular passion, particular poignancy; they then shift to more triumphant tones in other sections, juxtaposing the tragic and the joyous, the beautiful and the grotesque, the hateful and the compassionate. Ralph Wickiser's paintings would distill those emotions into color and through color, share the spirit of that profoundly human drama.

Lilly Wei

New York City, January 1996

In 1956, Wickiser left LSU to direct the art education division at State University of New York (SUNY) at New Paltz. During this time, he worked on his final and most popular book *An Introduction to Art Education* published in 1957 by World Book Company. The book brought Wickiser to the forefront of American art education. While at SUNY he hired Ilya Bolotowsky to teach, and his serious interest in photography as related to painting came to full bloom. While the contractors were building his house in New Paltz, they dug up huge boulders and left them in a pile in the backyard. He photographed them meticulously taking the same frame during different times of the year. It would be more than a decade later until he returned to the photographs of the boulders and painted them in a series *The Four Seasons*. This was also the beginning of a life-long interest in rocks as being animate objects, which he continued to paint in the *Reflected Stream series* from 1975 until the end of his life in 1998.

Compassion Series - *Theme Yellow*, 1954
Oil and mixed media on canvas, 90" x 73"

17

Wickiser always wanted to live in New York City, and after a brief stint at SUNY, New Paltz, he left to Chair the Undergraduate Art Department at Pratt Institute in Brooklyn. In 1959, his works were included in exhibitions at the Brooklyn Museum, Long Island University, and the Momentum Institute of Design in Chicago. In 1962, he created the Master of Fine Arts program at Pratt Institute and subsequently became the Director of the Division of Graduate Programs in Art and Design. The new program was one of a few of its kind in the United States at that time. During that time, faculty members included Ernie Briggs, Herman Cherry, Edward Dougmore, Franz Kline, Jacob Lawrence, George McNeil, Stephen Pace, and Philip Pearlstein. Wickiser formed close personal friendships with Jacob Lawrence, George McNeil, and Stephen

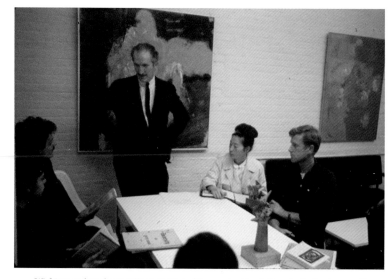

Wickiser and students at Pratt Institute (*Compassion II* paintings in the background)

Pace. In a series consisting mostly of 8' by 6' paintings *Compassion II*, he continued to paint in pure abstraction; however, the work now took on more of an expressionist feeling. Exhibitions continued at the Woodstock Artists Association in 1960, 1961, 1963, and 1969, and at Pratt, in 1960, 1966, and 1968 through 1971.

In the mid 60s, Wickiser became interested in the figure again when he began regularly attending studio sessions with other faculty members, George McNeil, Stephen Pace and Philip Pearlstein. At that point, Wickiser left seventeen years of painting abstractly and went back to his semi-realistic roots from the Chicago Art Institute pre-Depression days. However, in the figurative work, there was

Compassion II Series - *Decentergration*, 1960
Oil on linen, 84" x 72"

still abstraction. This series was based on photographs of the figure that he had taken, and the main theme was vanity and the apple, probably relating to the Garden of Eden. Many of the paintings were triptychs and involved the relationship between the figure and its reflection in the mirror. This was the beginning of his interest in reflections, and would remain a constant theme in his paintings, using different subject matter, for the rest of his life. He continued to paint this series for approximately seven years until 1972.

Nude Series - *Wendy*, 1973
Oil on linen, 36" x 36"

In the early 1970s Wickiser turned his attention to the photographs he had taken many years before of the boulders and painted the *Four Seasons* series. The series was exhibited in 1975 at the Pacem en Terris Gallery at the United Nations in New York. In these paintings, he started to synthesize abstraction and representation using all of the elements that he had been working with since the 1930s. Wickiser's style of synthesizing representation and abstraction as well as his deep-found interest in rocks as animate objects and painting rocks would continue for the rest of his life particularly in *The Reflected Stream series.*

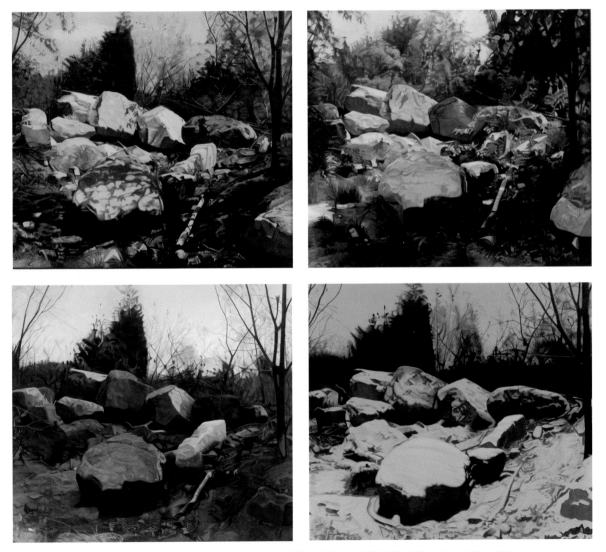

From a clump of boulders left by a bulldozer behind his house in New Paltz in the mid-50s, Wickiser meticulously photographed the changing light patterns of vivid textured rocks and earth, taking the identical frame at the same time each day, and transforming the images into The Four Seasons Series. Painted nearly fifteen years later, Wickiser's Four Seasons: Spring, Summer, Winter and Fall personifies the depth and breath of the philospher/painter's passion for seemingly innocuous forms of nature.

Lydia Wickiser Tortora
Long Island, NY, 1999

The Four Seasons Series - *Spring, Summer, Fall,* and *Winter,* 1972-1976, Oil on linen, 60" x 72"

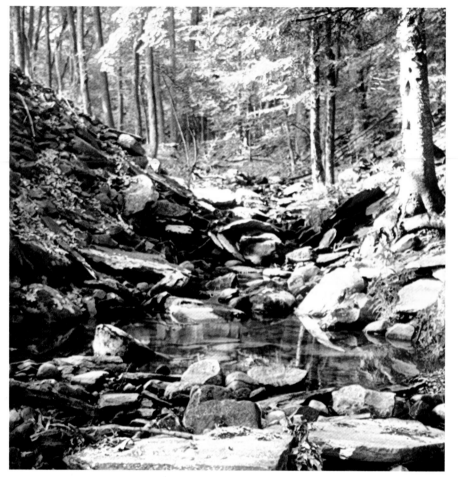

Photograph of Vredenburg Stream in Woodstock, NY by Ralph L. Wickiser ca. 1978

In 1975, Ralph and Jane retired to their house in Woodstock and Wickiser was finally able to realize his lifelong dream. It was at this point that the camera became an important tool in the discovery of his subject matter. He started photographing nature in Woodstock, especially the local streams, such as the Esophus. From this came the earliest series of his work on the stream which were primarily monochromatic. Then Wickiser discovered a little stream a couple of fields over from his studio called Vredenburg, and he began to make regular trips there to photograph. This was the beginning of his serious interest in reflections in the pools of water and he began taking hundreds of photographs of the reflections in those pools. Because the camera could see at high-speed and freeze these moments in time, a whole new world of vision opened up to him.

These are images that we see as moving video, but because they are moving very fast our mind does not still-frame them. The camera allowed him to still-frame nature in all its abstraction and to paint as it actually exists. The photographs were, however, only used as reference because ultimately he would paint in colors and forms unique to his style. In his choice of subject matter in the pools of the stream, he was particularly interested in and drawn to the ugliness in nature, because as he put it, "That's where the beauty is." As time went on, his paintings of the stream became more and more a synthesis of representation and abstraction.

During the 1960s and 1970s, he was included in *The Blue Book, Who's Who in America, Who's Who in the United States, Who's Who in American Art, Who's Who in the East, The National Register of Prominent Americans & International Notables, The New York Art Year Book,*

and numerous other professional publications. In 1974 and 1978, he had exhibitions at Harriman College in Harriman, NY and in 1976 and 1978, at the Lotus Gallery, one of Soho's first galleries. In 1977, his works were included at Nassau County Community College in Long Island, NY. In 1978, works were included in Ulster County Community College. Throughout the 1980s his works were shown in galleries in Boston, New York and Washington, D.C.

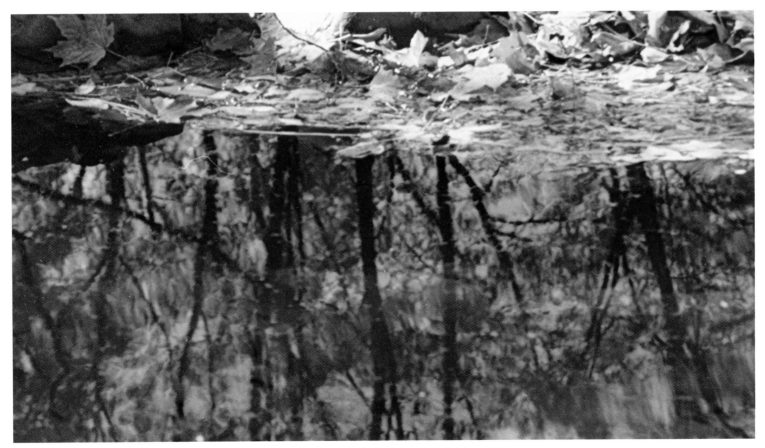

Photograph of Vredenburg Stream in Woodstock, NY by Ralph L. Wickiser ca. 1982

Ralph and Jane Wickiser in front of Gallery 630 B,
New Orleans, LA, 1990

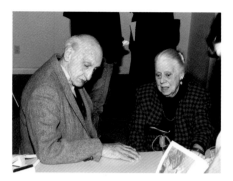

George McNeil and Jane Wickiser at Z Gallery, 1991,
Soho, NY

(Left to Right) Ralph, Stephen Pace, Walter Wickiser,
and Judd Tully at Ralph's Opening in 1997, Soho, NY

Beginning in 1985, Wickiser's paintings of the stream begin to evolve into a purer form of abstraction. This marked a radical departure from the stream as he had painted it from 1975 to 1985. From 1985 until his death in 1998 the stream continued to be a source of inspiration and synthesis of representation and abstraction.

In 1990, Wickiser returned to New Orleans, Louisiana, to exhibit at Gallery 630 B. It was a sentimental journey for my mom, dad, and me after an absence of almost thirty-five years. Wickiser received a heart-felt welcome home as a Louisiana artist. That year, I also became a director of one of the first galleries in America from mainland China, the Z Gallery in New York City and Wickiser showed there with painters of the Star Star Group from Beijing. Eventually, I opened my own gallery in Soho, NY in 1992, and held several exhibitions where Wickiser was reunited in show with his old friends, George McNeil, and Stephen Pace. In 1993, Wickiser exhibited at the Haenah Kent Gallery in Soho, NY, and in 1994 he exhibited at the Haenah Kent Gallery in Seoul, Korea. In 1997, there was a solo exhibit of his work at The Gallery at the Roundabout Theatre in Times Square, NY. Several television programs were made by Images Art, New York, and shown on Manhattan and Paragon Cable Television Channels. During the 1990s, his exhibits were reviewed by *ARTnews*, *Art in America*, *The New York Times*, *Asahi Art Pictorial*, Tokyo, Japan, and *Art Vision*, Tokyo, Japan.

Crowd at Ralph's Opening at Z Gallery, 1991, Soho, NY

Claude Monet tended and obsessively painted his Japanese water garden in Giverny and Frederic Edwin Church laid claim on canvas to the magnificent vistas of the Hudson River and launched an art movement in its name. These true stories, like Cézanne's penchant for ripe fruit and Degas' for bathers, have entered the pantheon of art history.

The cumulative gaze of those legendary artists of the late 19th and early 20th centuries continues today with the abstract landscapes paintings by the octogenerian New York artist Ralph Wickiser. Since the mid-1970s Wickiser has relentlessly painted a seemingly innocuous stream (The Vredenberg Brook) behind his home and studio in the bucolic township of Woodstock.

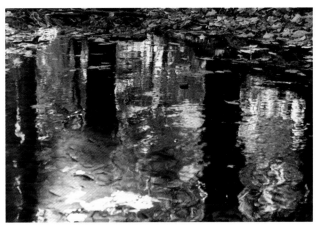

Photograph of Vredenburg Stream by Ralph L. Wickiser, ca. 1978

It is challenging to imagine that such a narrow stretch of crystal clear water could occupy the brush and musing intellect of a major figure in American art education, whose roots are deeply associated with the rise of American Modernism. But over and over, like a secret mantra, Wickiser has mined images from this modest stream (photographing changing light conditions amidst the armada of color-flecked rocks and grasses) producing painting after painting.

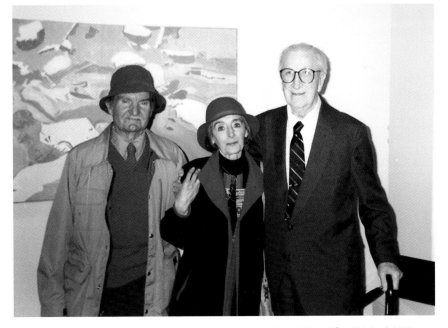

Stephen and Pam Pace with Ralph Wickiser at Walter Wickiser Gallery, Soho, NY, April, 1997
Purple Rock, 1996, Oil on linen, 40" x 60"

Purple Rocks from 1996 is a haiku of painterly forms. The initial impressions from high-speed film are transformed into lyrical abstractions that can just as easily resemble the terrain as seen from weather satellite photography. Reflections of the beautifully shaped rocks skitter off the canvas, supplying the viewer with a rich cluster of grand illusions. One thinks briefly of the Surrealist-influenced Rothko as well as the alien beachscapes of Yves Tanguy. But it is pure Wickiser, contemplating and constructing another jewel-like facet of his beloved (albeit, excessively examined) stream.

Judd Tully
New York City, March 1997

23

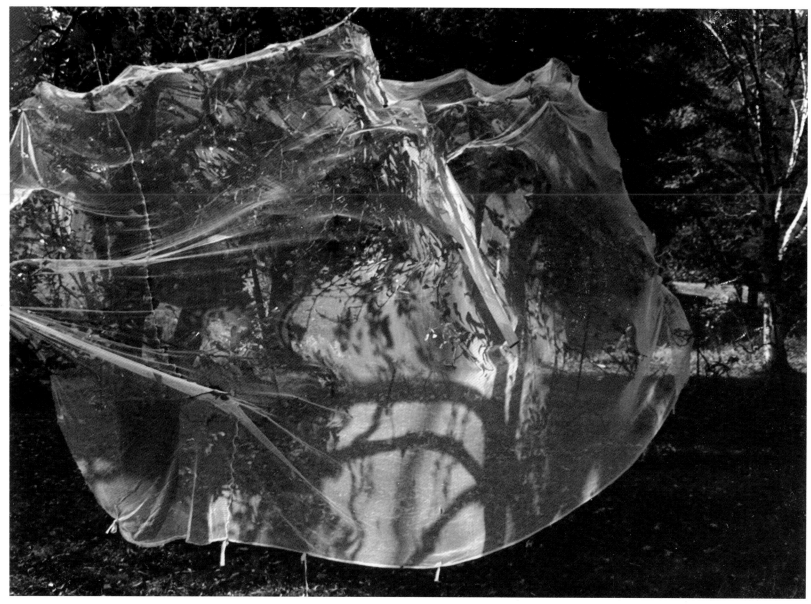

Photograph of Covered Apple Tree taken by Ralph L. Wickiser, Woodstock New York, 1991

Around 1987, looking for new ideas Wickiser began photographing his apple trees which he covered with cheese cloth to keep away the birds. Like a beautifully draped human, the light patterns and reflections of the limbs and leaves created a whole new world which Wickiser continued to paint for the ensuing years.

In 1996, Wickiser became interested in the varied shapes and patterns on the grass created by the reflected shadows of our backyard trees in Woodstock. This was the last series that he would work on but he continued to work on all three series, *The Reflected Stream*, *The Covered Apple Tree* and *Shadows on the Grass* simultaneously during the last years.

He continued to walk the 200-foot, grass-worn path to his studio to paint as he had done for the past forty-nine years right up until three months before he passed away in October, 1998.

—WALTER WICKISER, 2009

Red on Black, 1996
Oil on linen, 24" x 20"

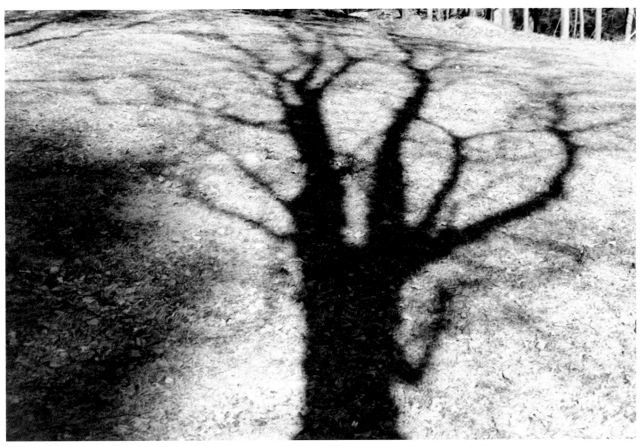

Photograph of Shadows on the Grass taken by Ralph L. Wickiser, Woodstock New York, 1998

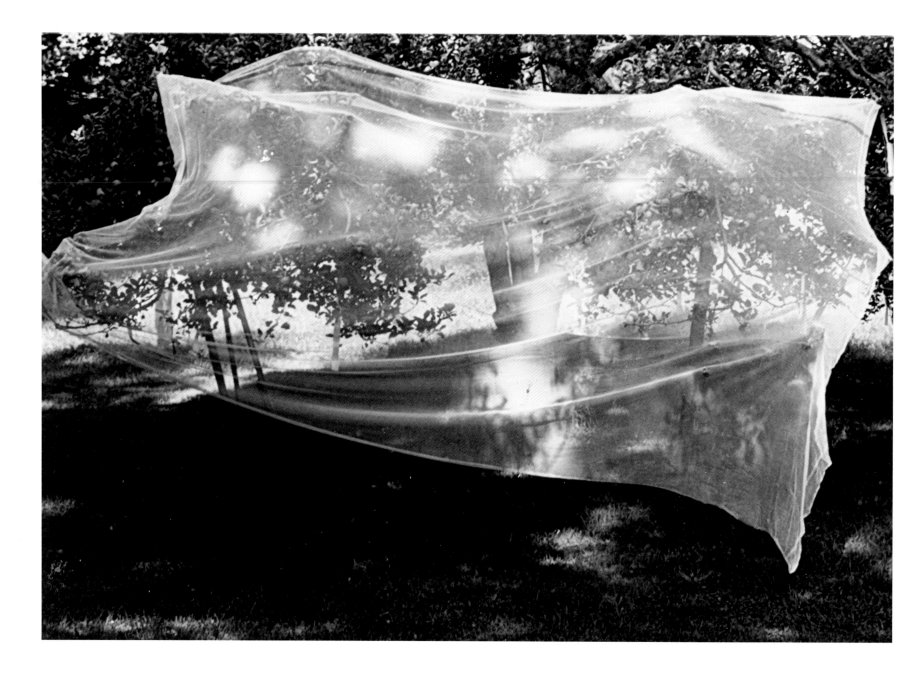

Photograph of Covered Apple Tree taken by Ralph L. Wickiser, Woodstock, NY, 1988

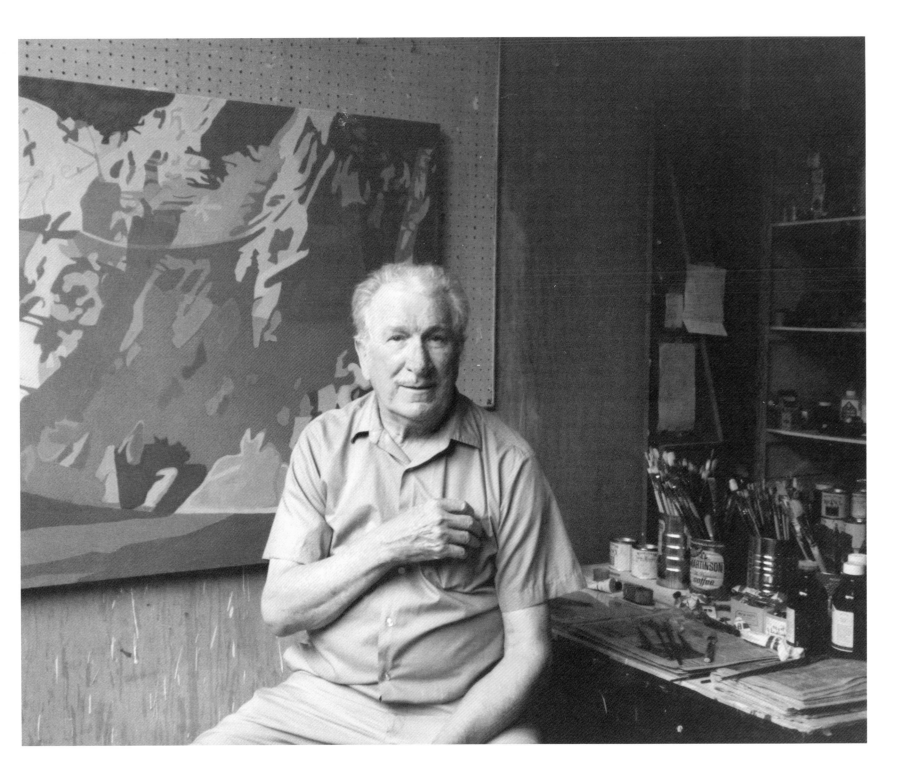

Ralph L. Wickiser in His Studio in Woodstock, NY, ca. 1990

THE COVERED APPLE TREE 1987-1998

BLUEBERRY NET, 1987, OIL ON LINEN, 30" x 42"

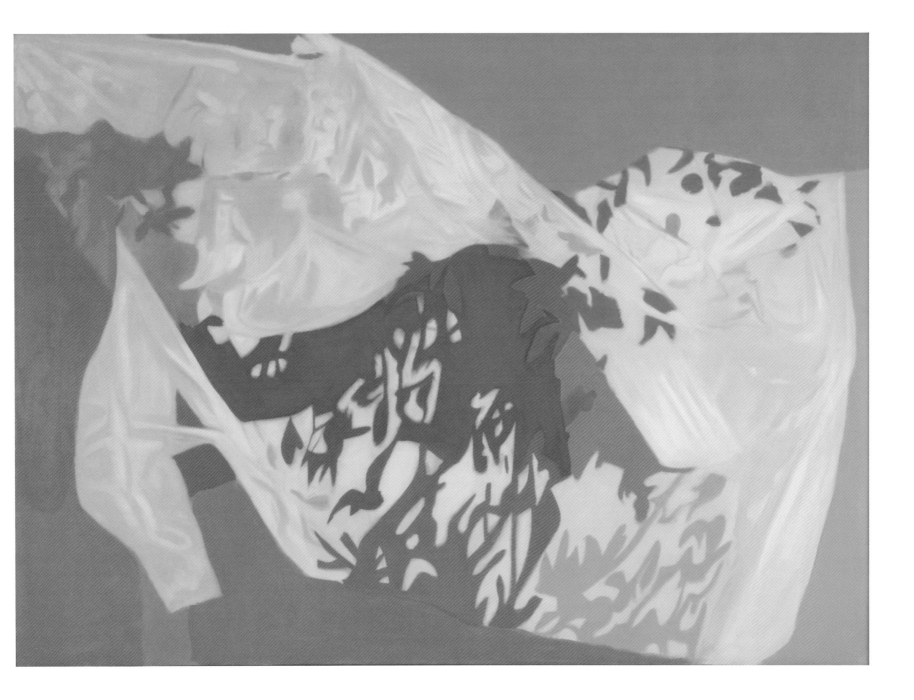

PURPLE NET, 1987, OIL ON LINEN, 30" x 50".
COLLECTION OF MR. & MRS. RICHARD ALLEN, NY

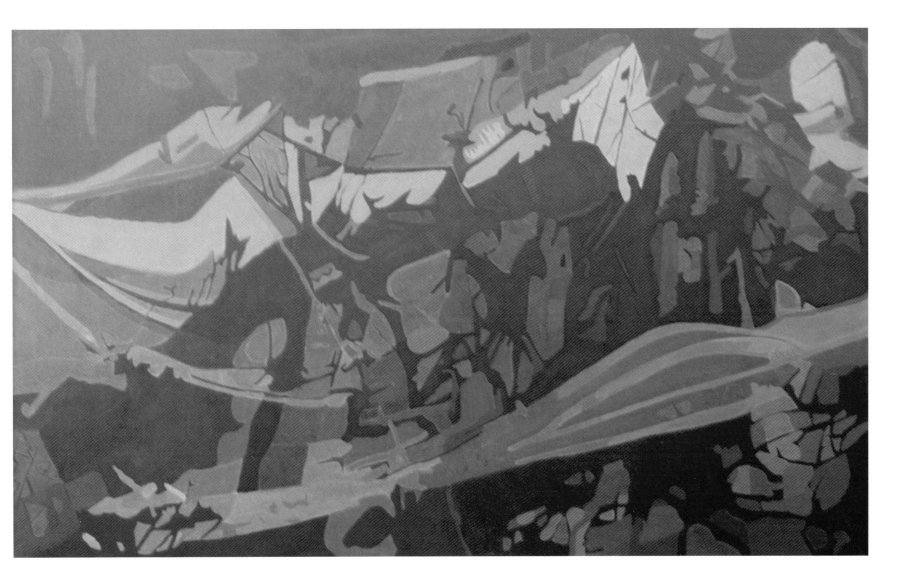

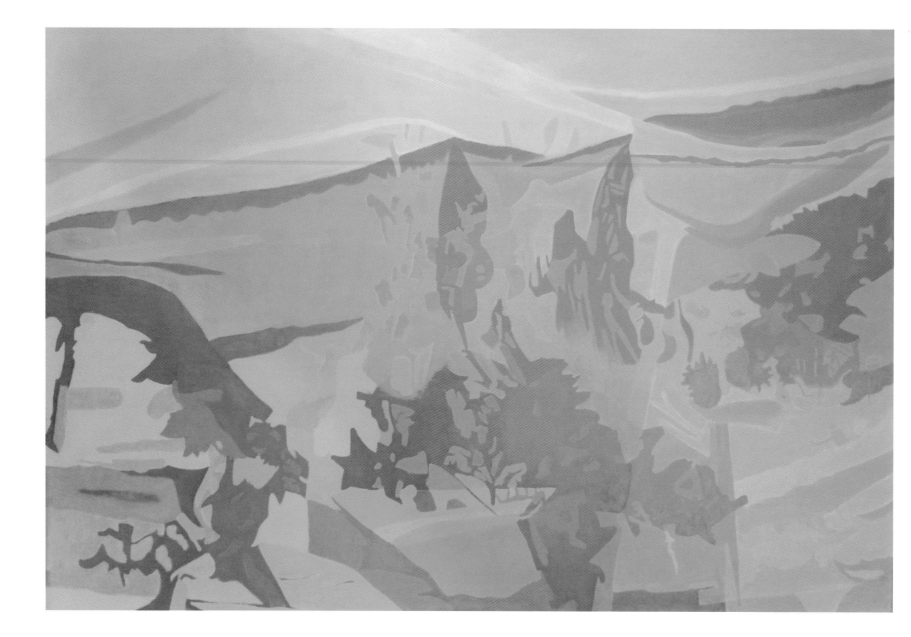

ENIGMA, 1990, OIL ON LINEN, 40" x 60"

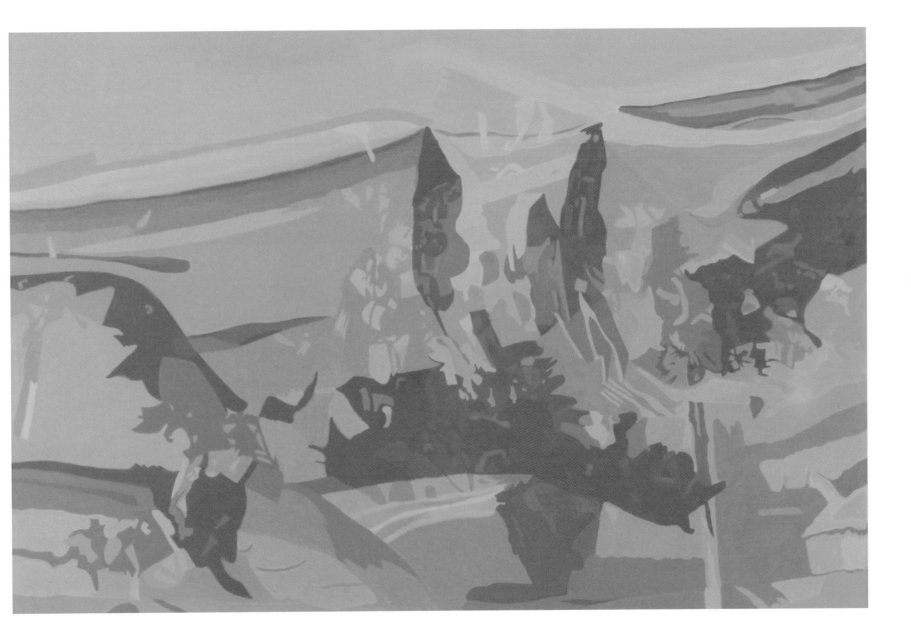

APPLE TREE NET BEIGE, 1990, OIL ON LINEN, 47" x 70"

APPLE TREE GREEN, 1989, OIL ON LINEN, 47" x 70"

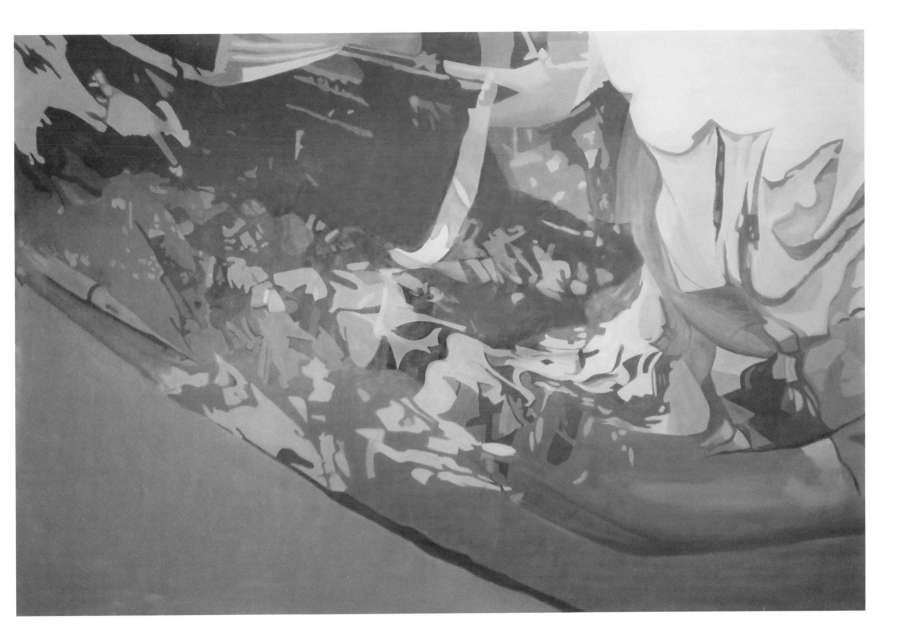

APPLE TREE NET, 1989-90, OIL ON LINEN, 47" x 70"

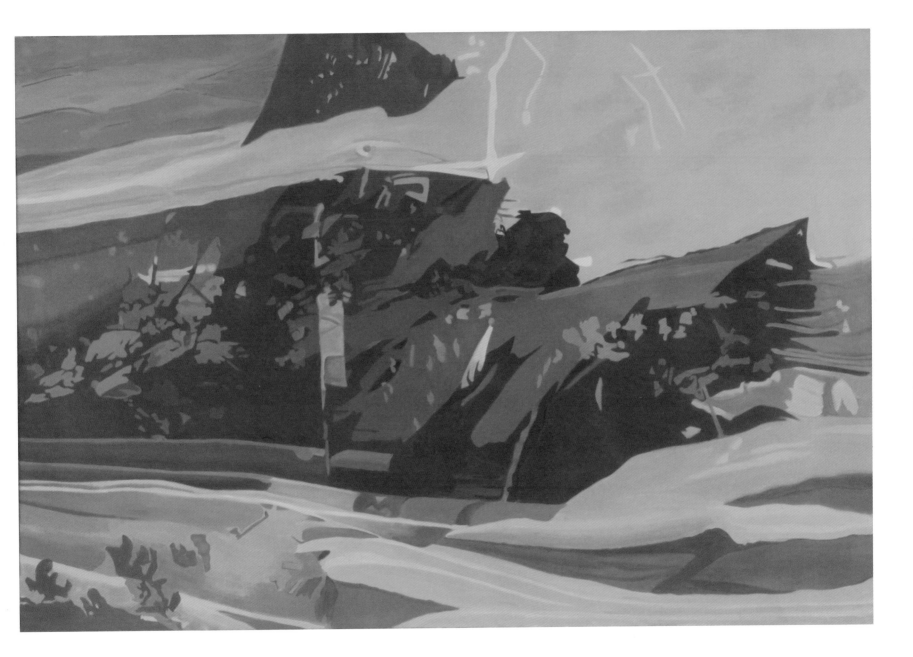

PINK NET, 1988, OIL ON LINEN, 47" x 70"

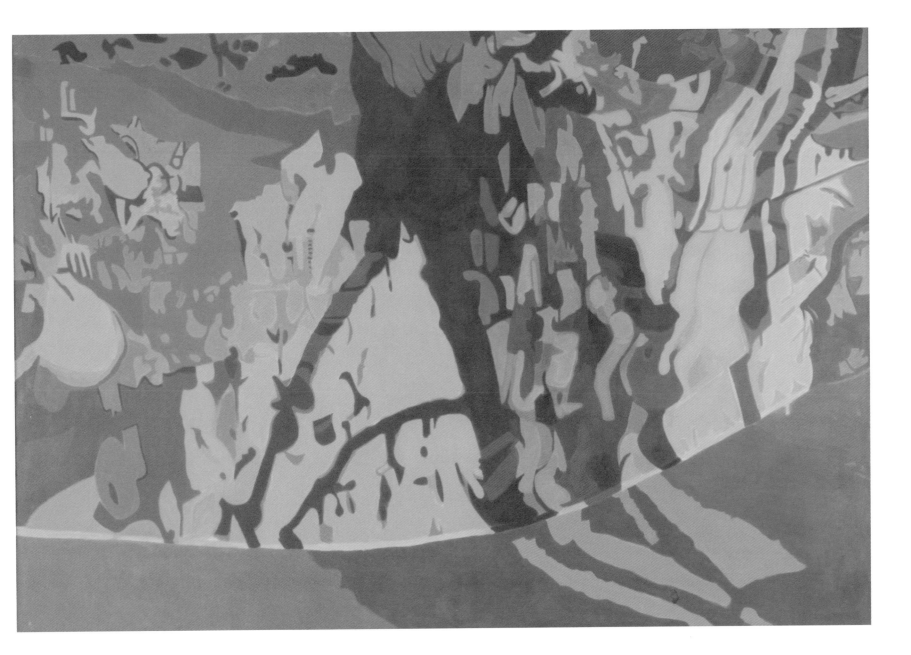

BEIGE NET, 1988, OIL ON LINEN, 47" X 70"

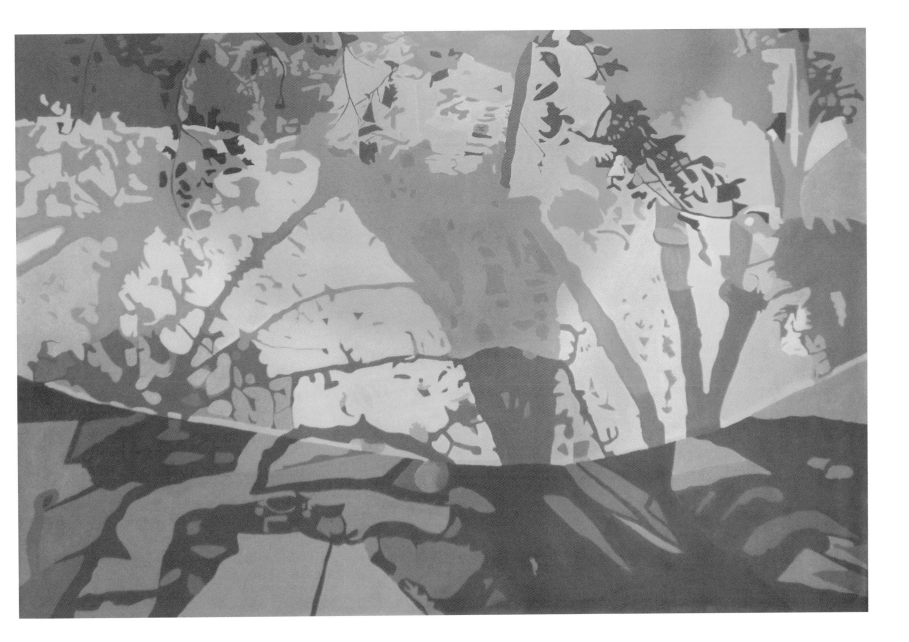

Electric, 1990, Oil on Linen, 40" x 60"

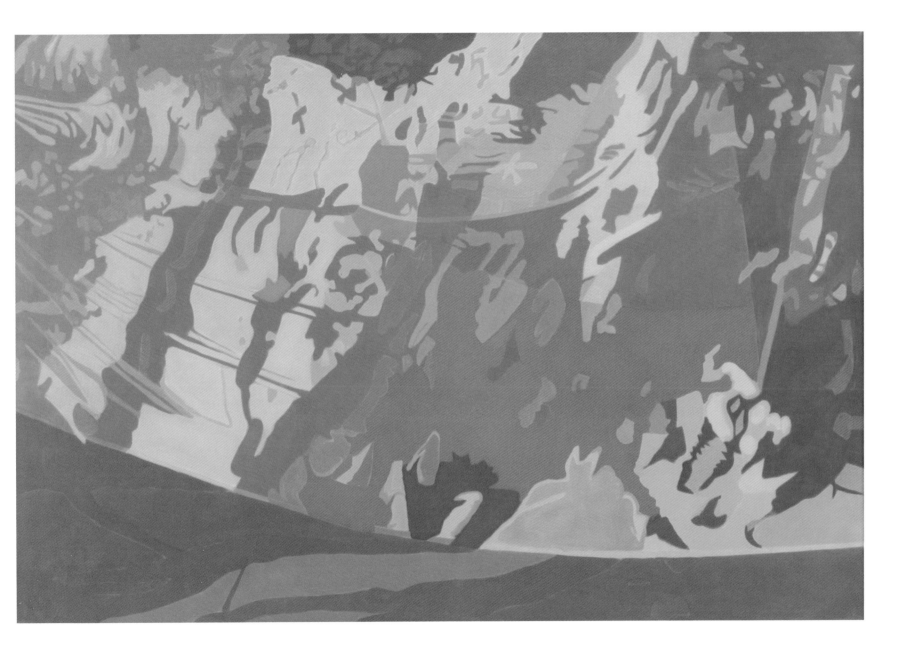

BLUE NET, 1990, OIL ON LINEN, 36" x 50"

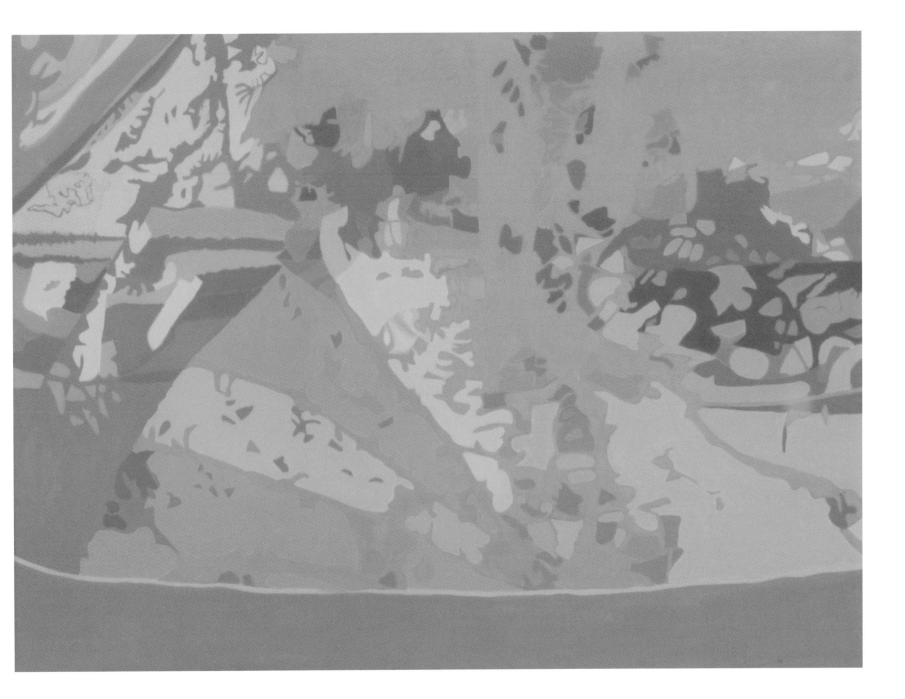

SHEET ON THE APPLE, 1990, OIL ON LINEN, 24" x 30"

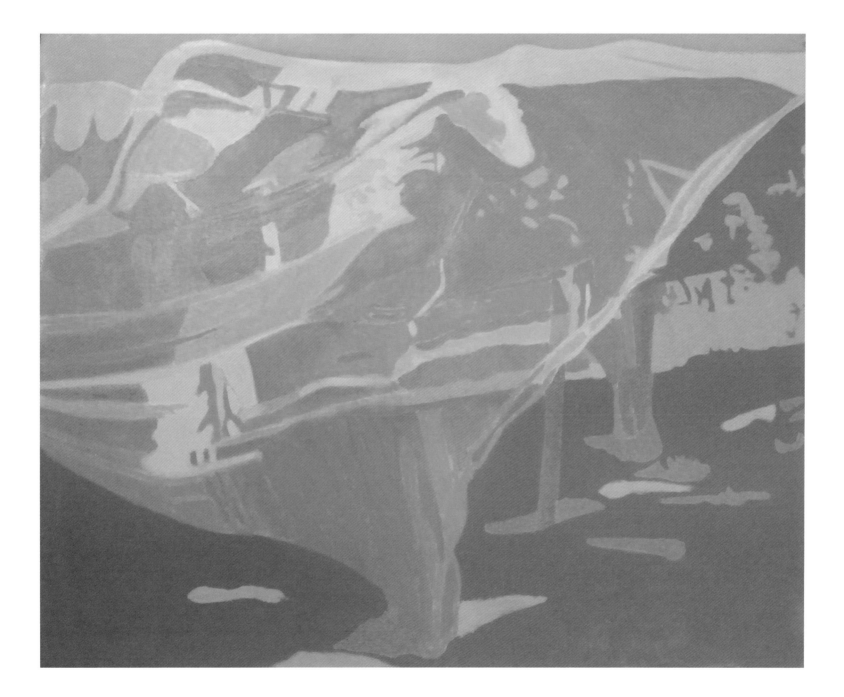

IN PURPLE, 1990, OIL ON LINEN, 24" x 20"

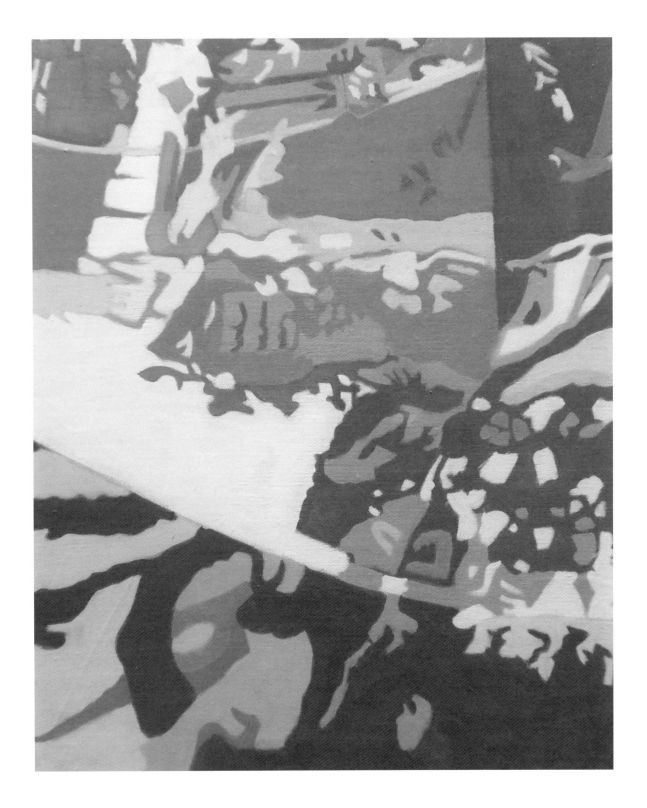

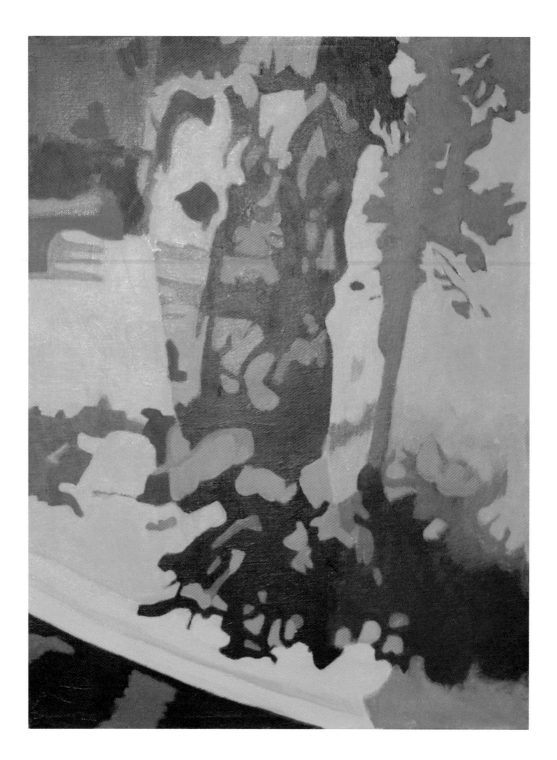

THE APPLE TREE, 1991, OIL ON LINEN, 16" x 12"
COLLECTION OF MR. & MRS. ROBERT SCHWAGERL, NY

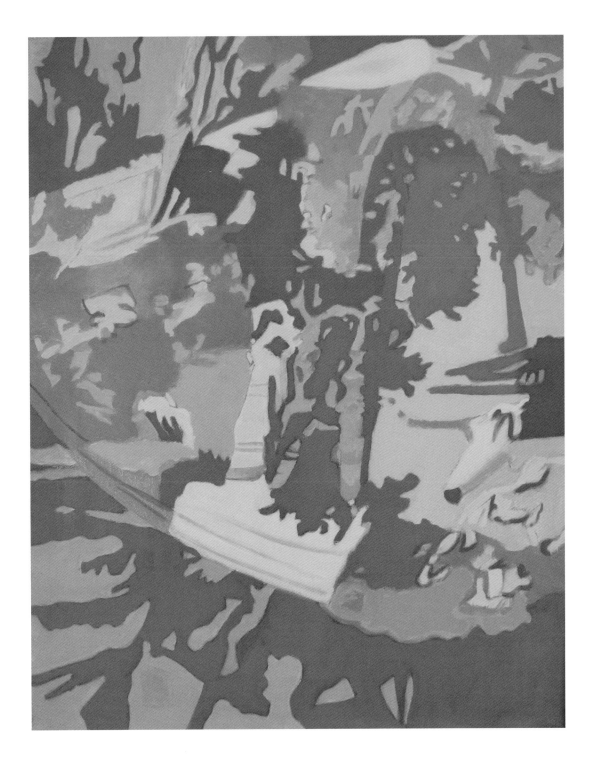

GREENS, 1990, OIL ON LINEN, 20" x 16"
COLLECTION OF MR. & MRS. ROBERT SCHWAGERL, NY

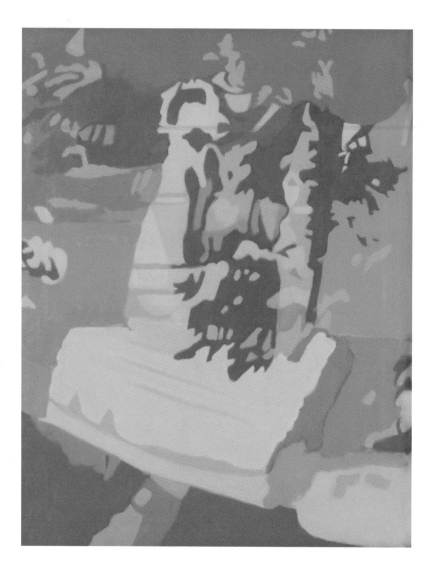

SHADOW ON THE APPLE TREE
1990, OIL ON LINEN, 20" x 16"

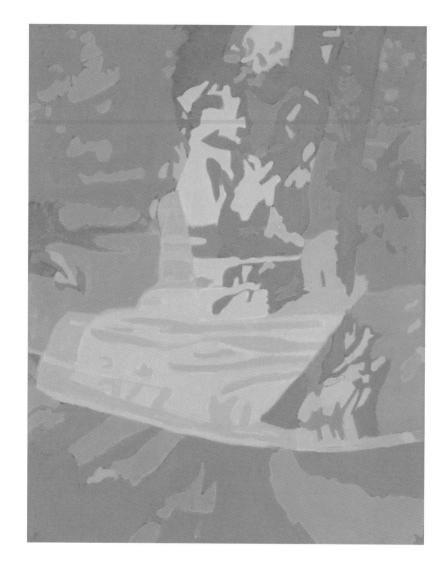

APPLE TREE NET BLUE
1990, OIL ON LINEN, 20" x 16"

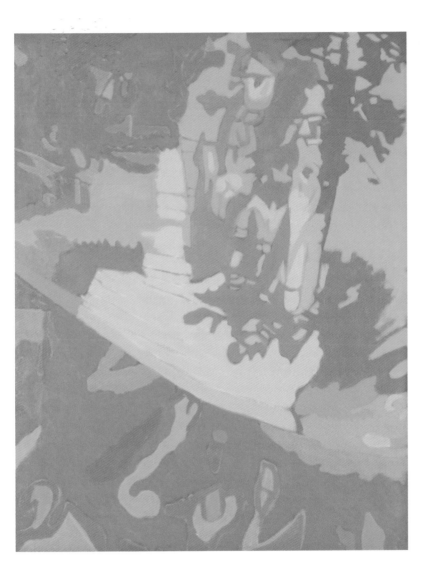

Apple Tree in Yellow
1990, Oil on Linen, 20" x 16"

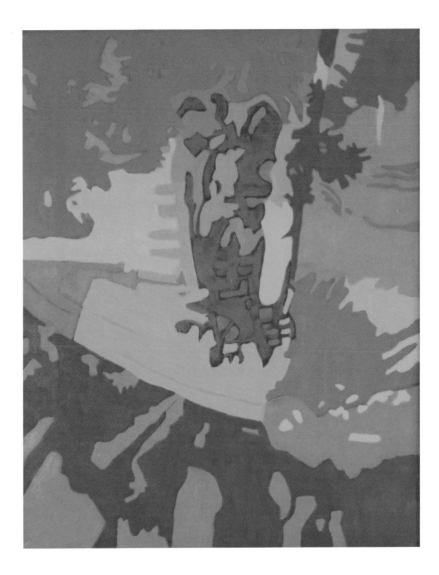

In Red
1990, Oil on Linen, 20" x 16"

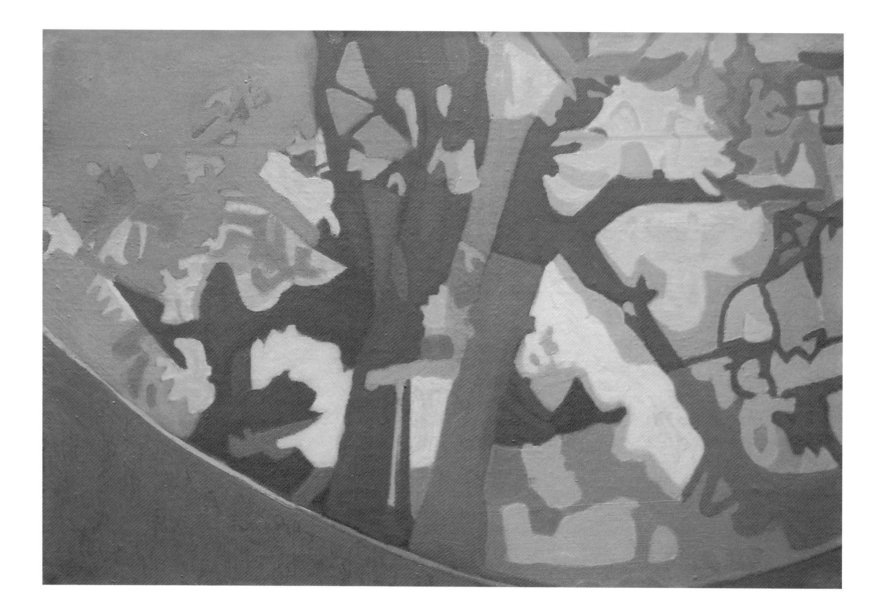

RED APPLE TREE (GREEN TREE), 1990, OIL ON LINEN, 12" X 18"

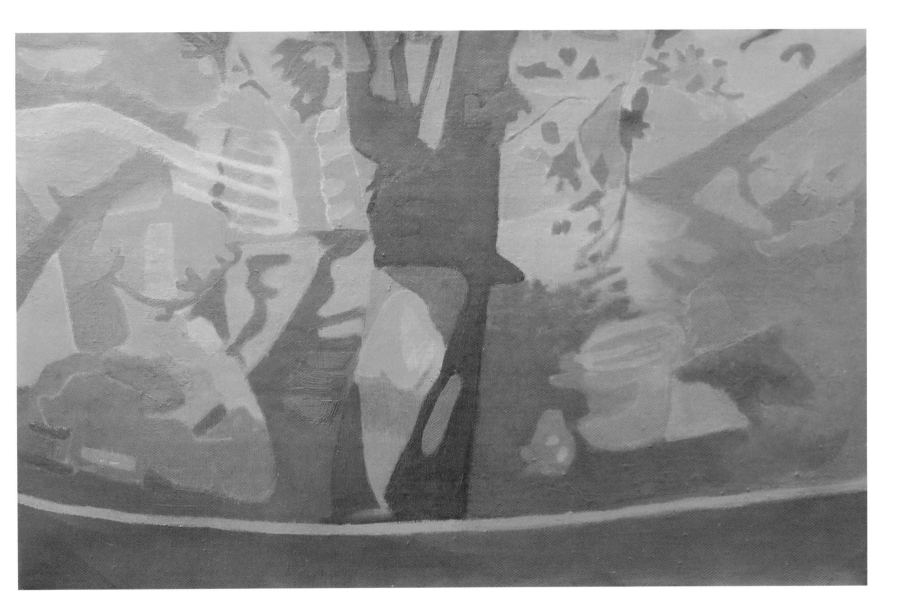

RED ALL OVER, 1993, OIL ON LINEN, 10" x 16"
COLLECTION OF MR. HIRO NOZUKA, NY

PINK APPLE TREE, 1998, OIL ON LINEN, 10" X 8"

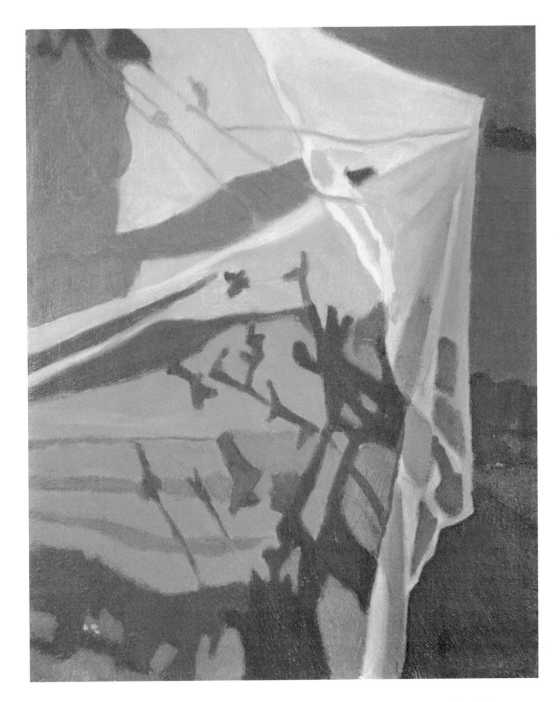

APPLE TREE NET GREEN, 1990, OIL ON LINEN, 10" x 8"
COLLECTION OF MR. AND MRS. DAVID WORTH, NC

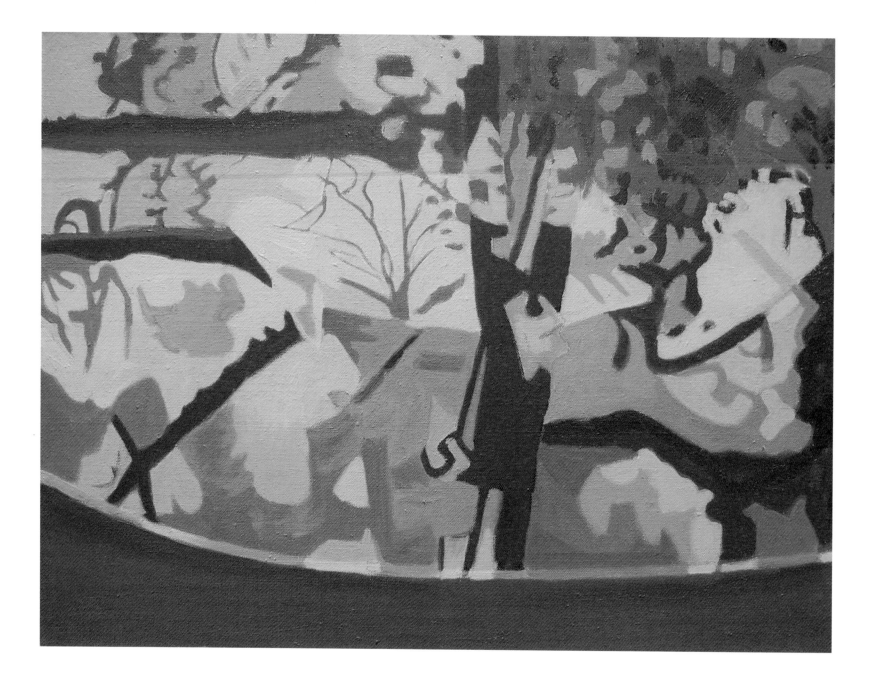

GREEN TREE, 1991, OIL ON LINEN, 12" x 16"

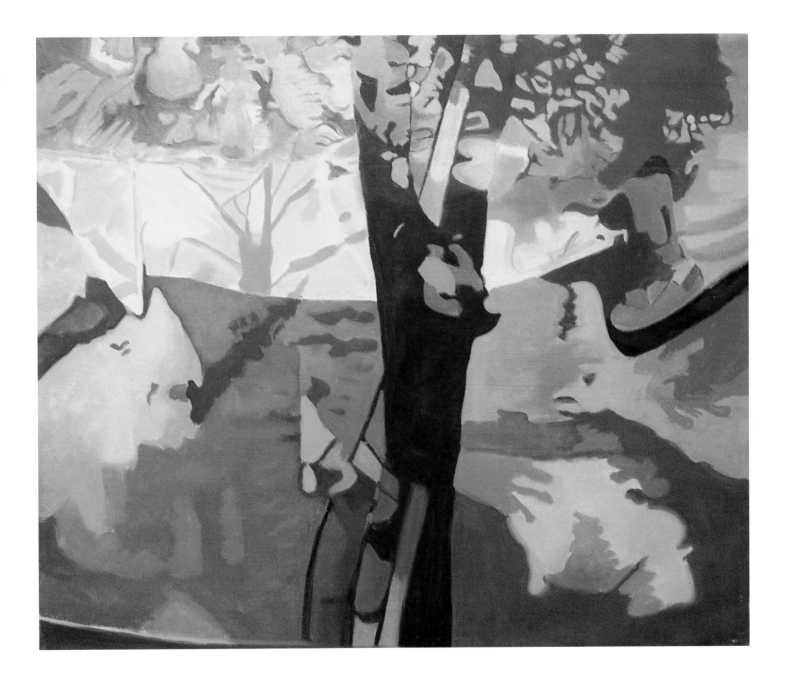

APPLE TREE II, 1992, OIL ON LINEN, 20" x 24"

THROUGH THE NET, 1991, OIL ON LINEN, 26" x 40"

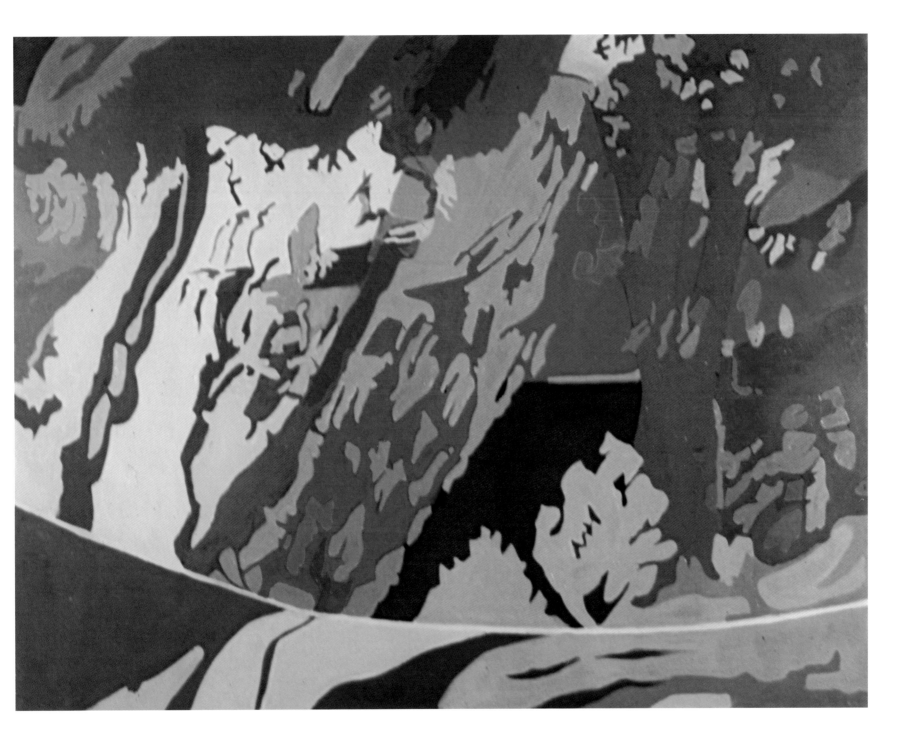

ATOM, 1991, OIL ON LINEN, 26" x 40"

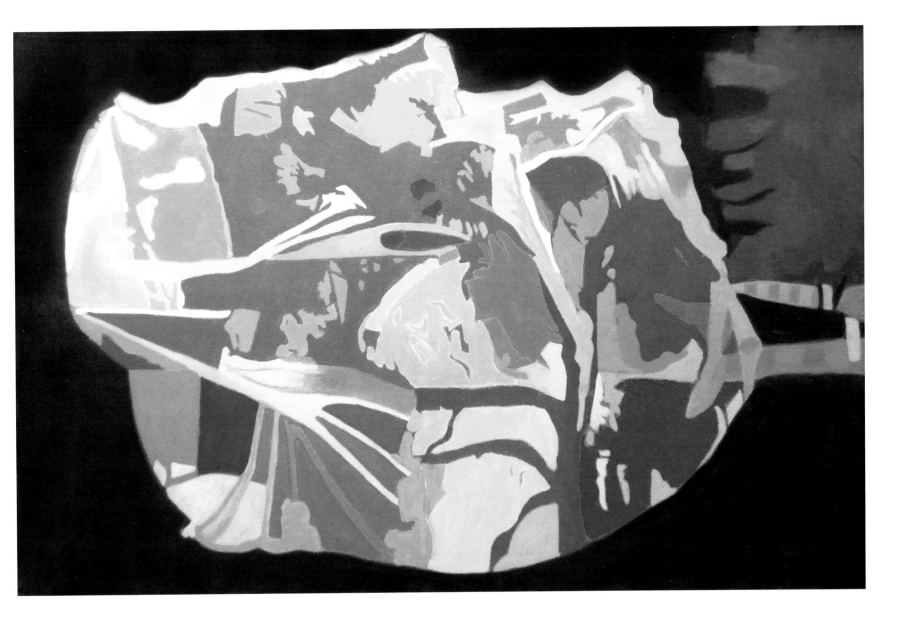

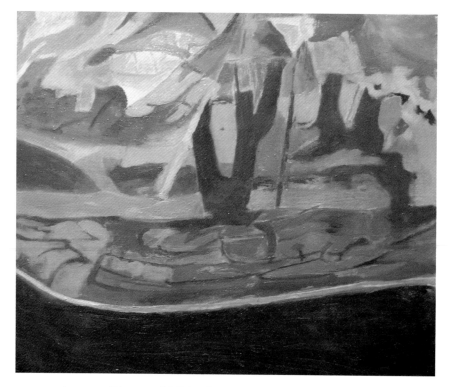

APPLE TREE, 1996, OIL ON LINEN, 12" x 14"

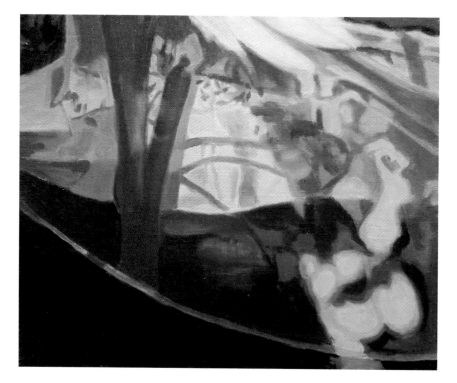

COVERED APPLE TREE, 1993, OIL ON LINEN, 8" x 10"

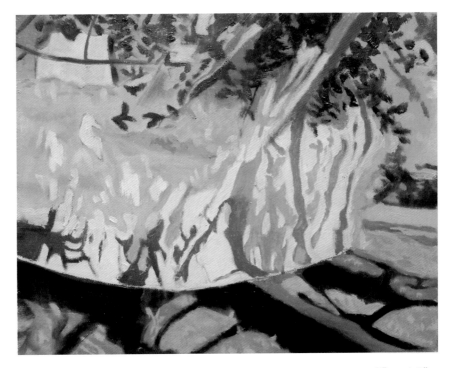

APPLE TREE WITH NET, 1993, OIL ON LINEN, 8" x 10"
COLLECTION OF MR. AND MRS. DAVID WORTH, NC

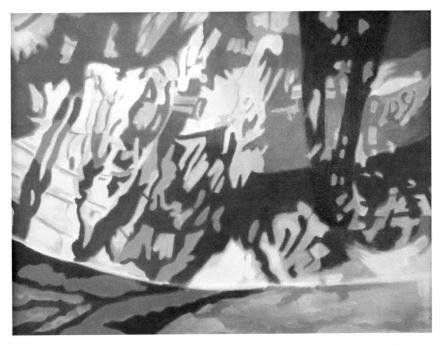

COVERED TREE, 1991, OIL ON LINEN, 12" x 16"

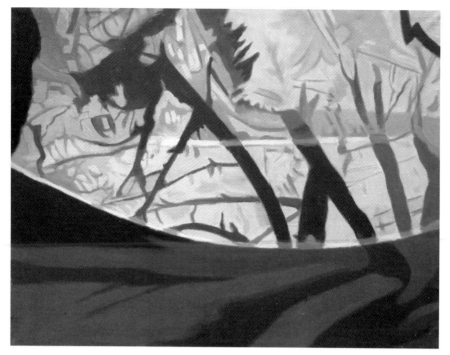

STUDY IN GREEN, 1993, OIL ON LINEN, 12" x 16"

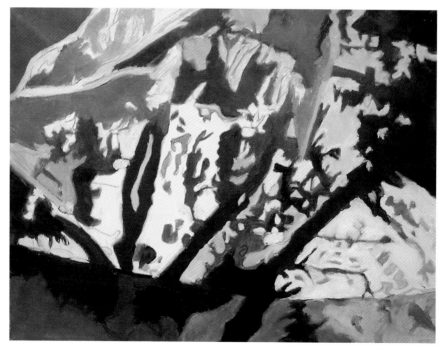

COVERED APPLE TREE, 1994, OIL ON LINEN, 12" x 16"

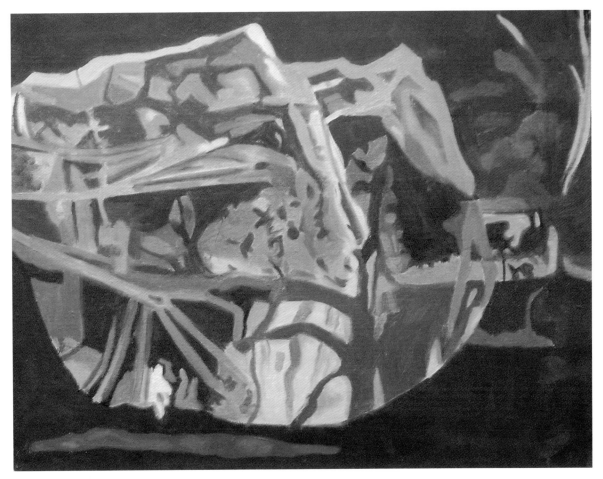

SHADED APPLE TREE, 1991, OIL ON LINEN, 12" X 16"

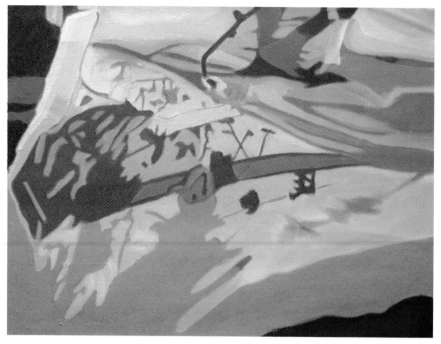

PATTERNS FROM A TREE, 1991, OIL ON LINEN, 12" x 16"

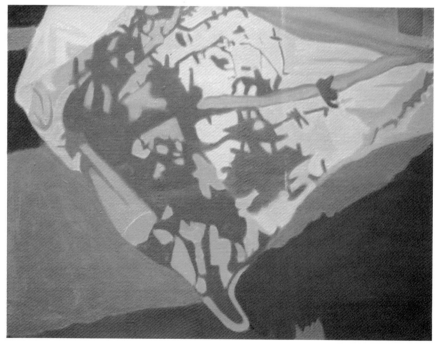

COVERED TREE II, 1991, OIL ON LINEN, 12" x 16"

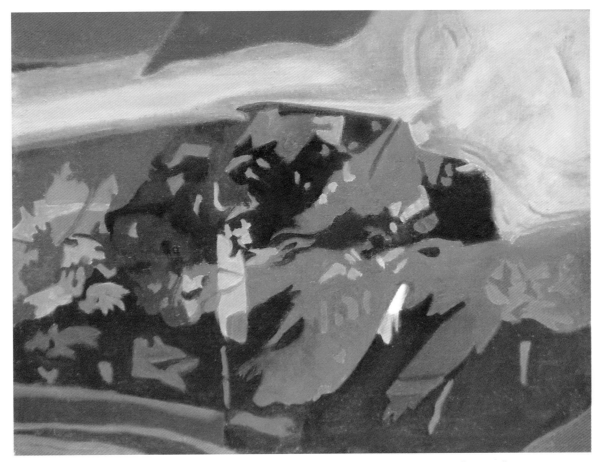

APPLE TREE NET PINK, 1991, OIL ON LINEN, 12" x 16"

INTO THE WOODS, 1995, OIL ON LINEN, 26" X 34"

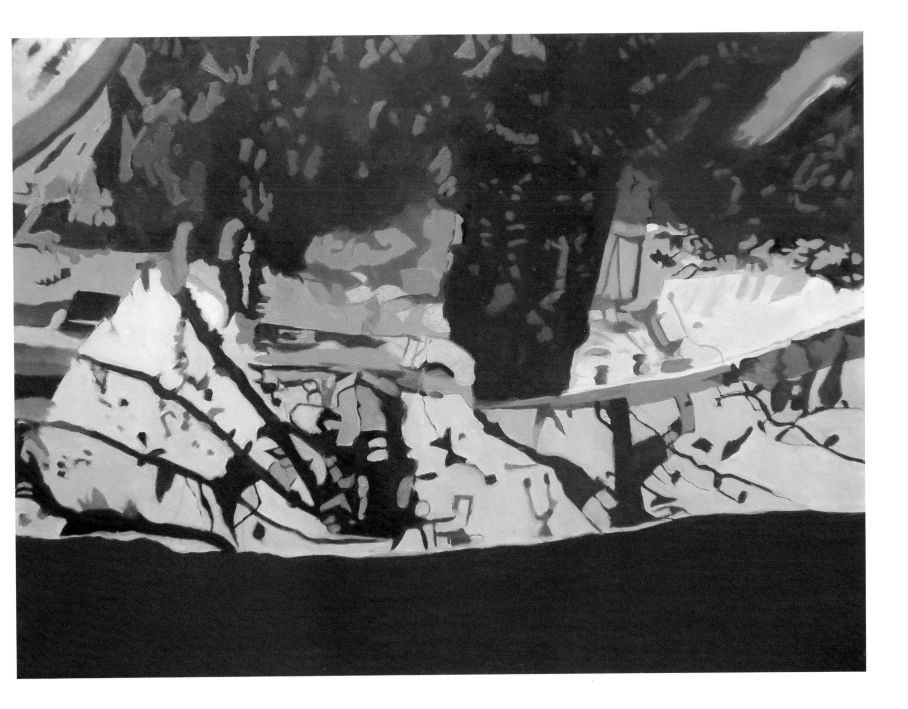

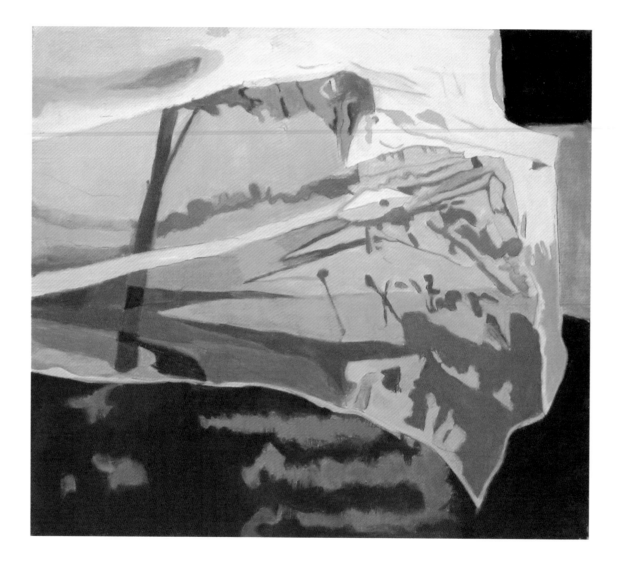

GREEN APPLE TREE, 1996, OIL ON LINEN, 16" x 18"

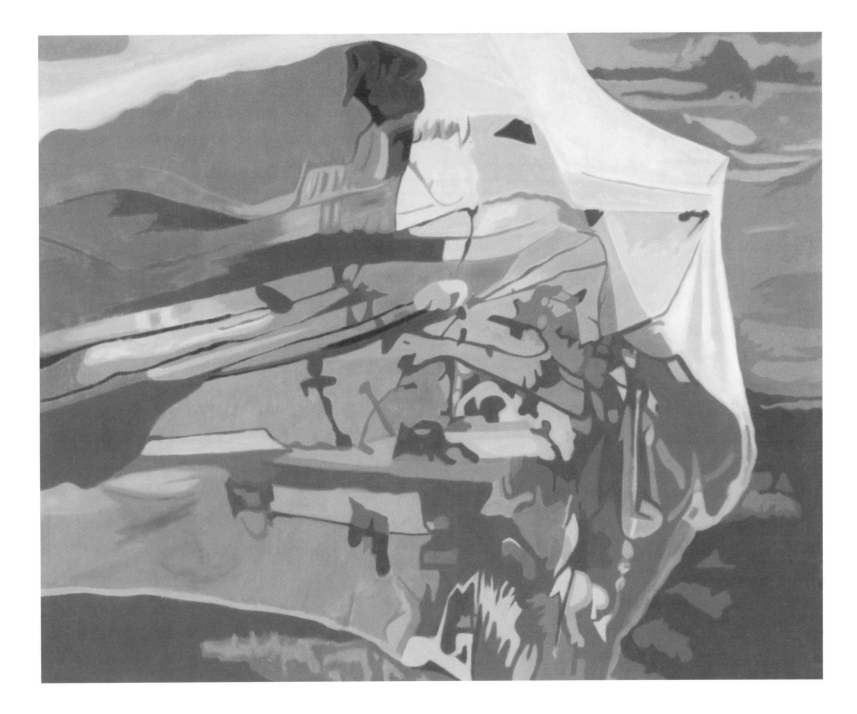

BLUE NET, 1990, OIL ON LINEN, 40" x 50"

NET II PURPLE, 1990, OIL ON LINEN, 40" x 50"

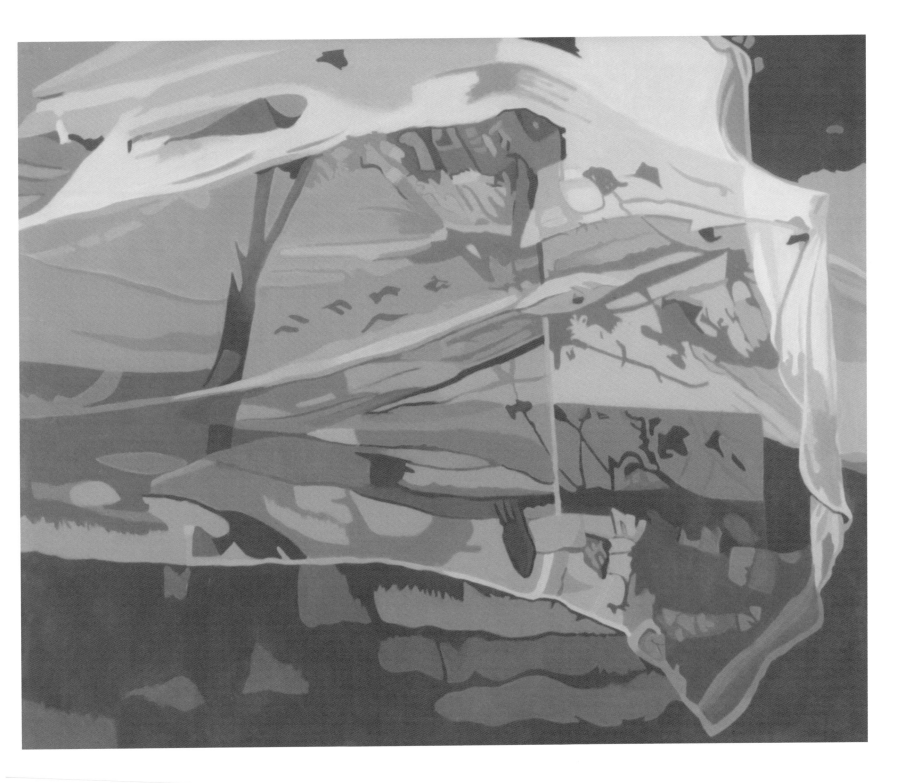

GREEN NET, 1990, OIL ON LINEN, 40" x 50"

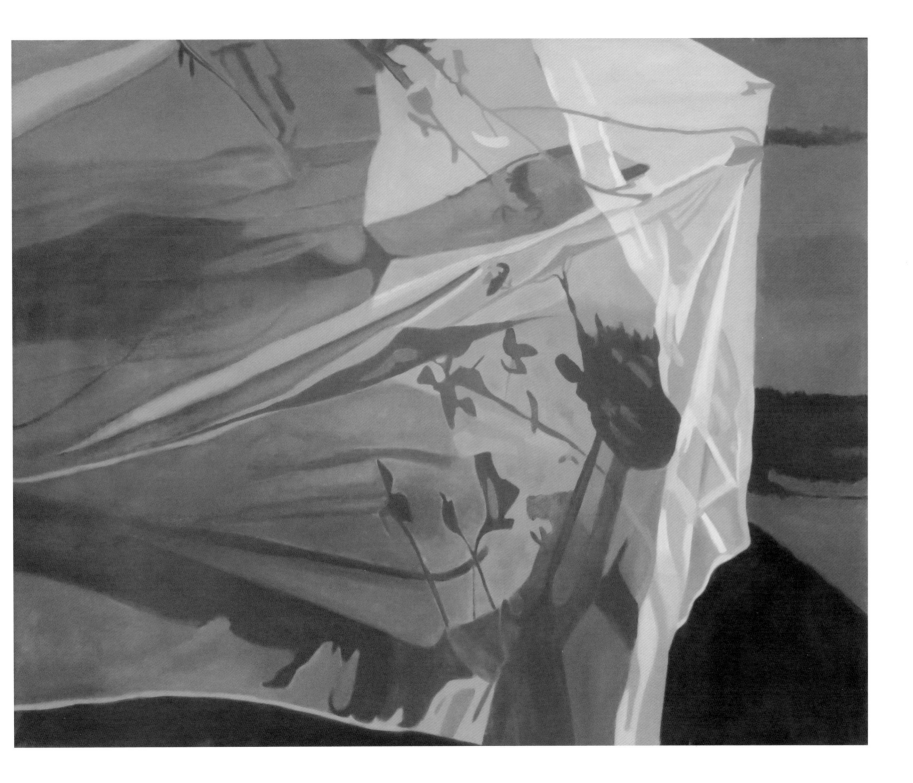

PURPLE NET, 1994-96, OIL ON LINEN, 40" x 50"

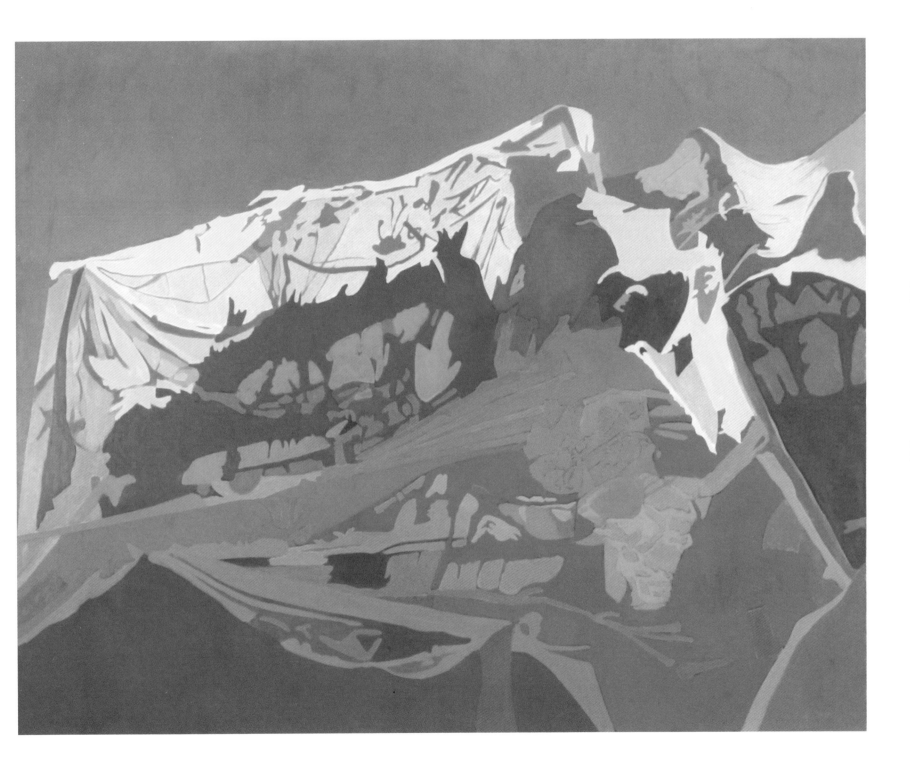

PATTERNS, 1995, OIL ON LINEN, 40" X 50"

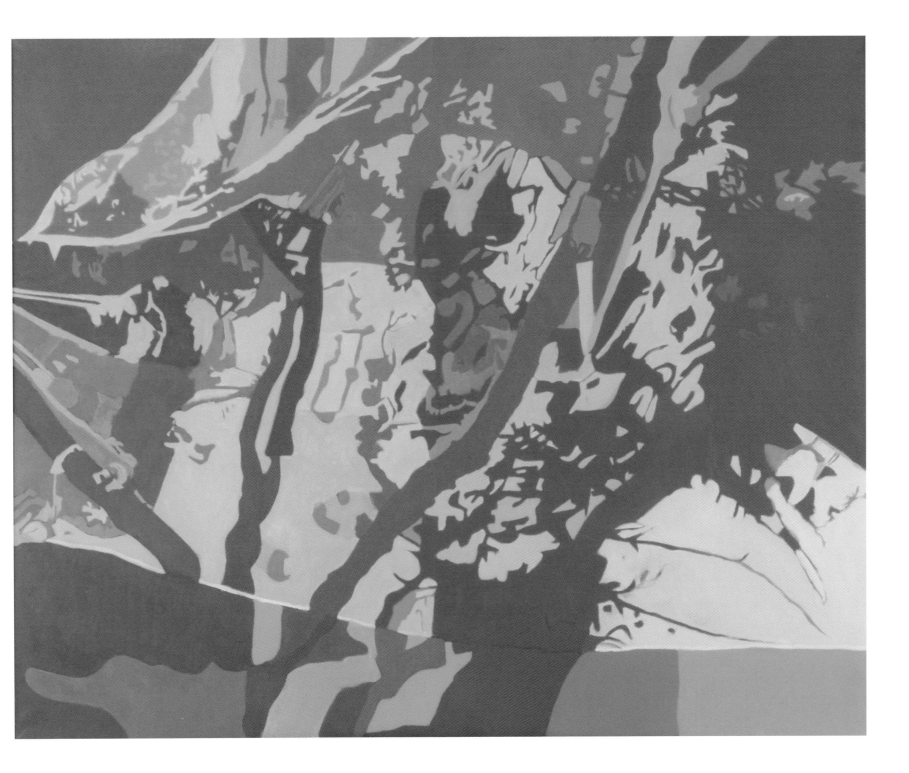

NET, 1993, OIL ON LINEN, 40" x 50"

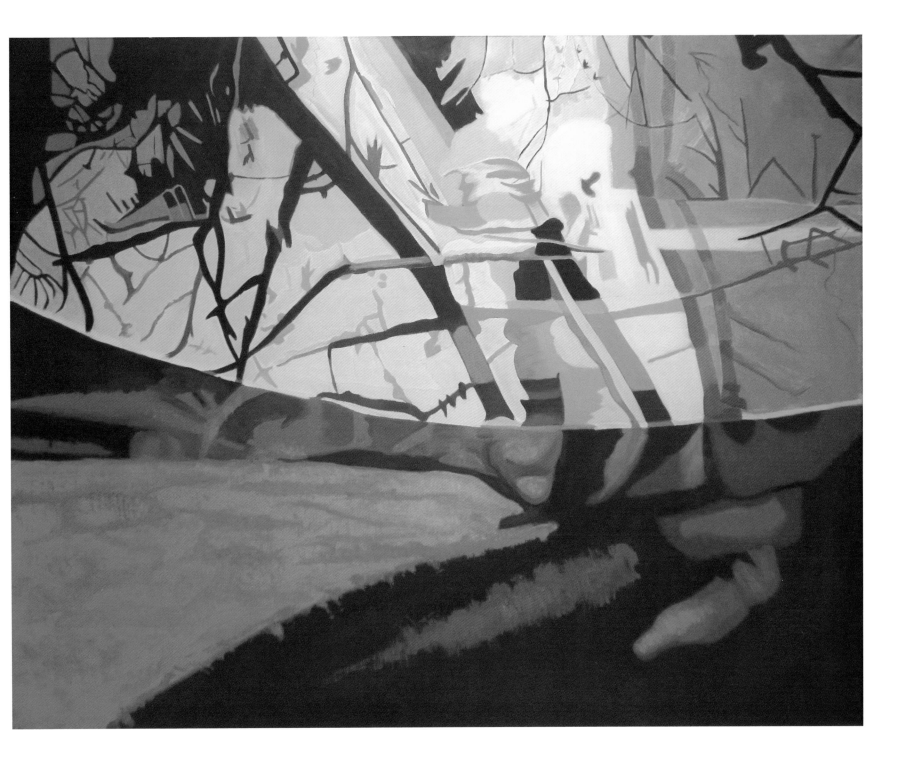

GREEN LIMB, 1991, OIL ON LINEN, 36" x 50"

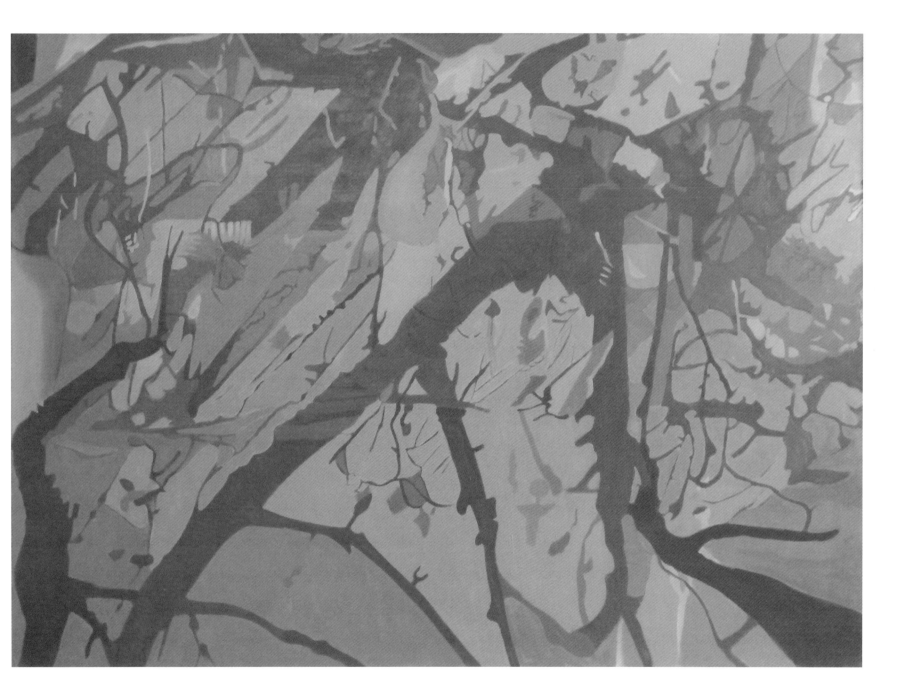

PURPLE TREE II, 1992, Oil on Linen, 26" x 40"
COLLECTION OF MR. & MRS. RICHARD ALLEN, NY

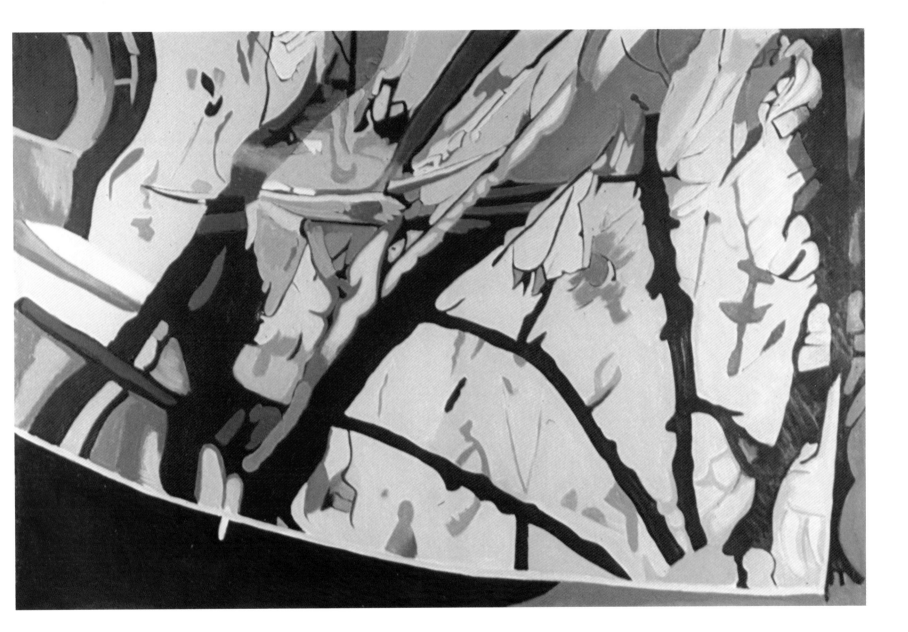

COVERED APPLE TREE, 1994, OIL ON LINEN, 40" x 50"

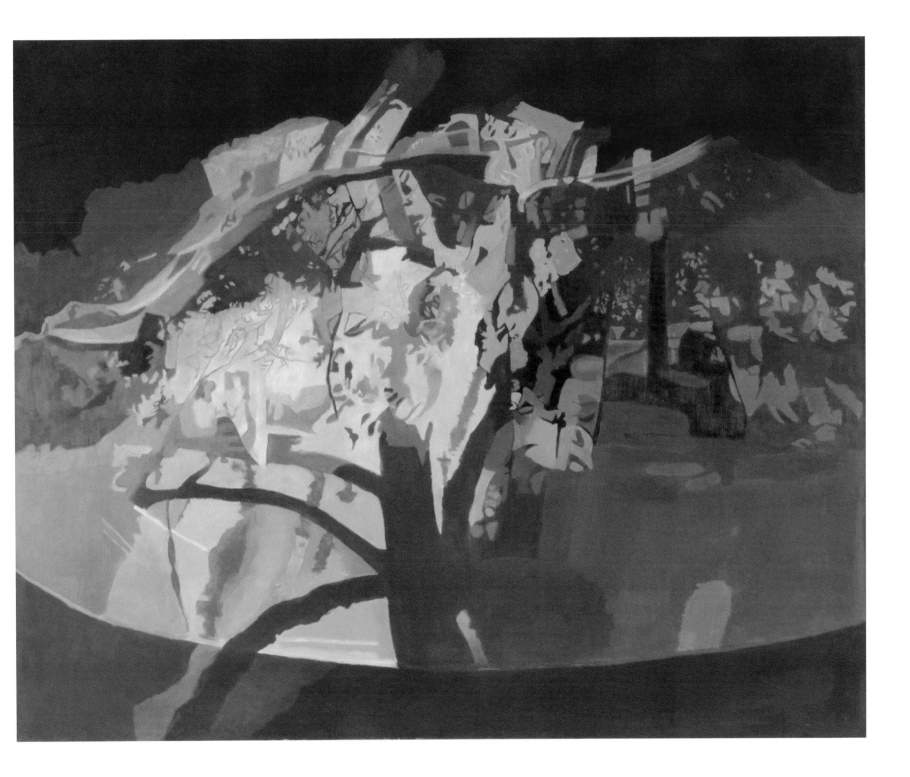

BLUE APPLE TREE, 1990-96, OIL ON LINEN, 36" x 50"

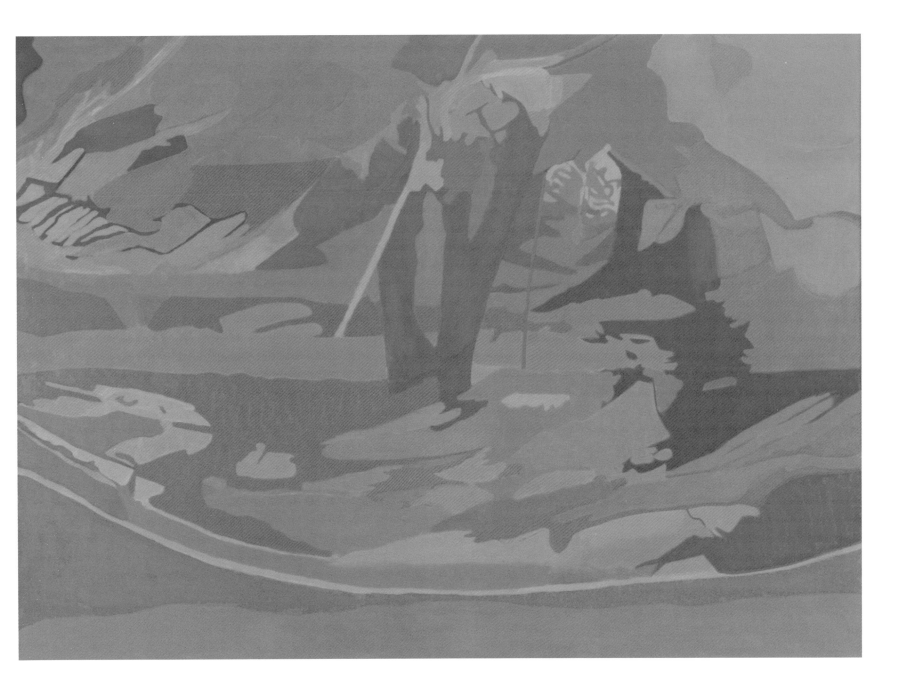

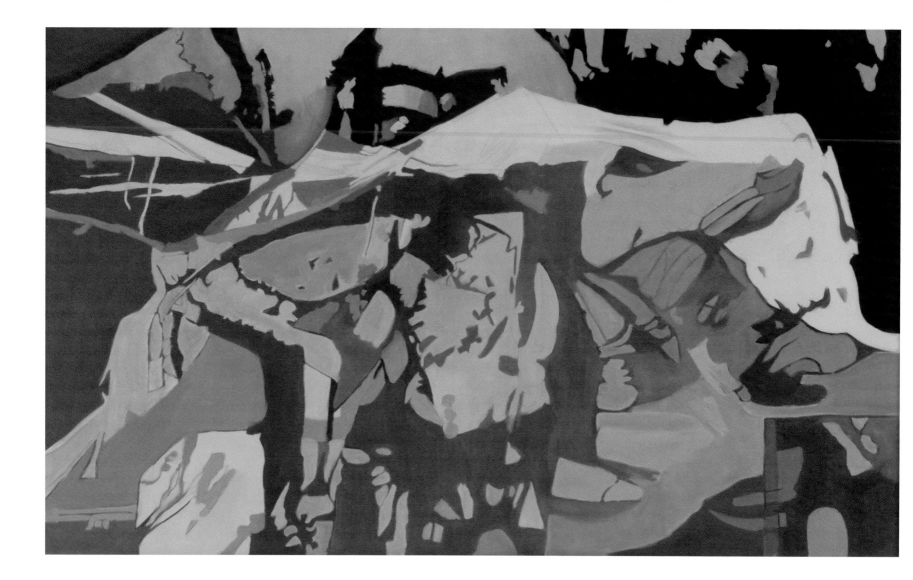

BEIGE APPLE TREE, 1998, OIL ON LINEN, 30" X 50"

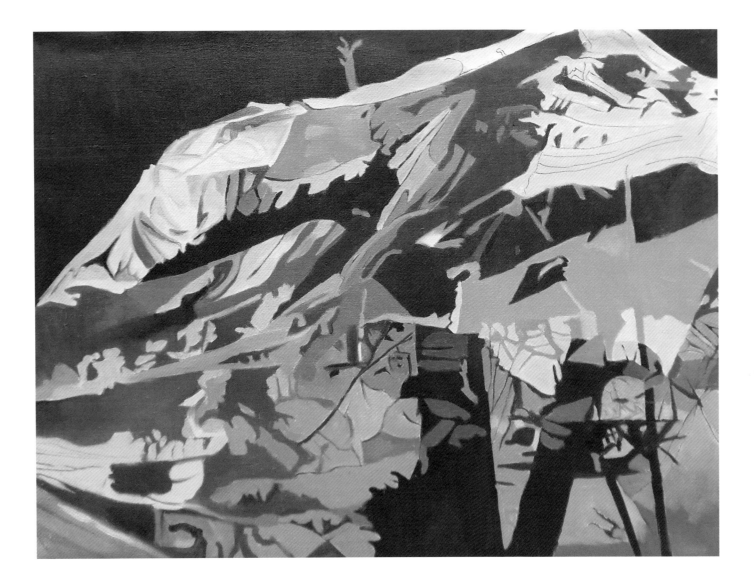

COVERED TREE, 1994, OIL ON LINEN, 18" X 24"

ARCHINE APPLE TREE, 1993, OIL ON LINEN, 26" x 40"
COLLECTION OF MS. LUCY YU FEI CHEN, NY

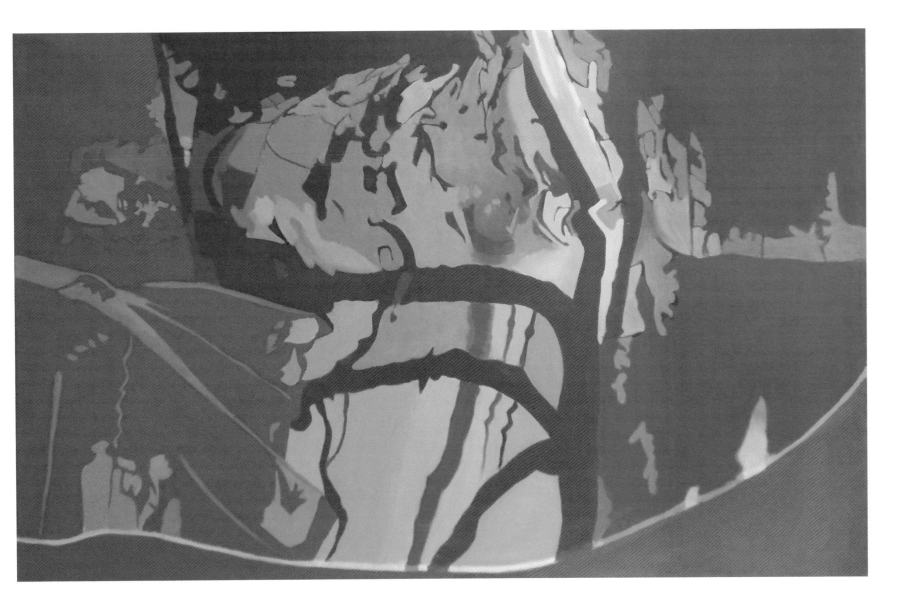

COVERED TREE II, 1992, OIL ON LINEN, 36" x 50"

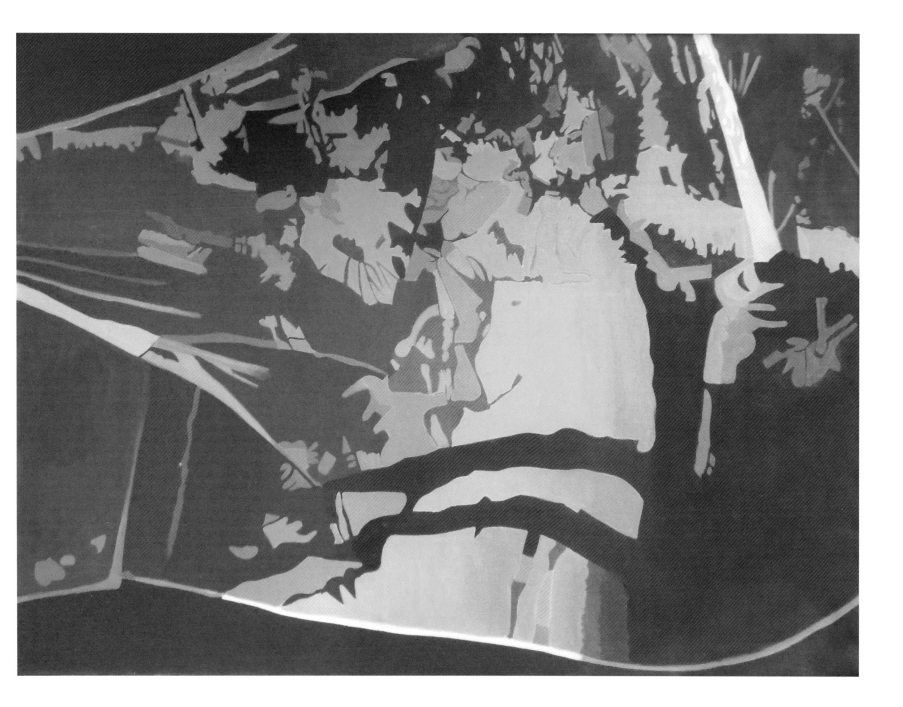

IN YELLOW, 1994, OIL ON LINEN, 36" X 50"

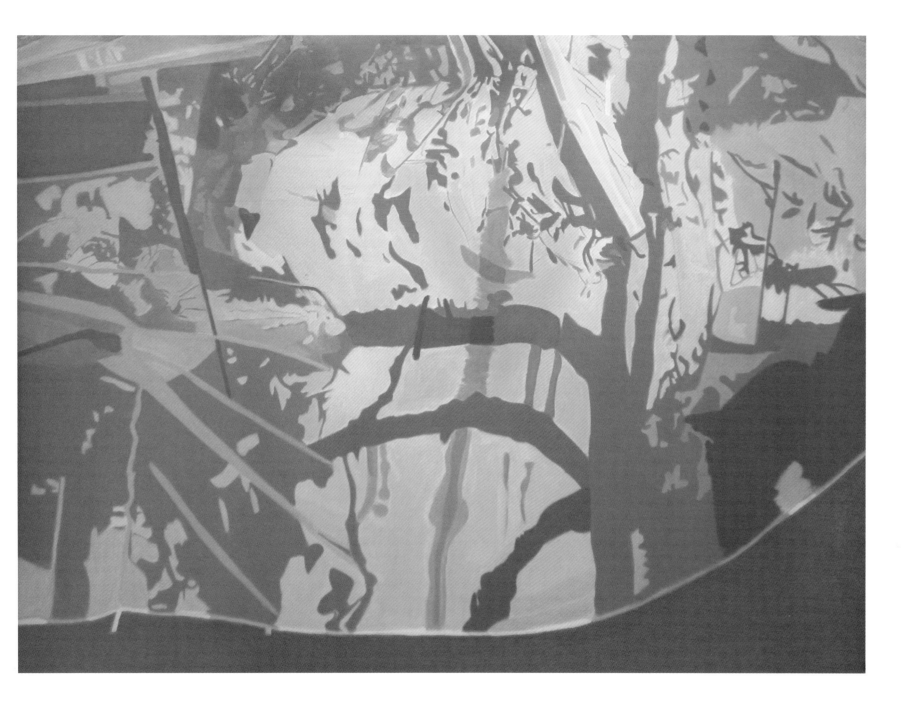

COVERED APPLE TREE, 1998, OIL ON LINEN, 36" x 50"

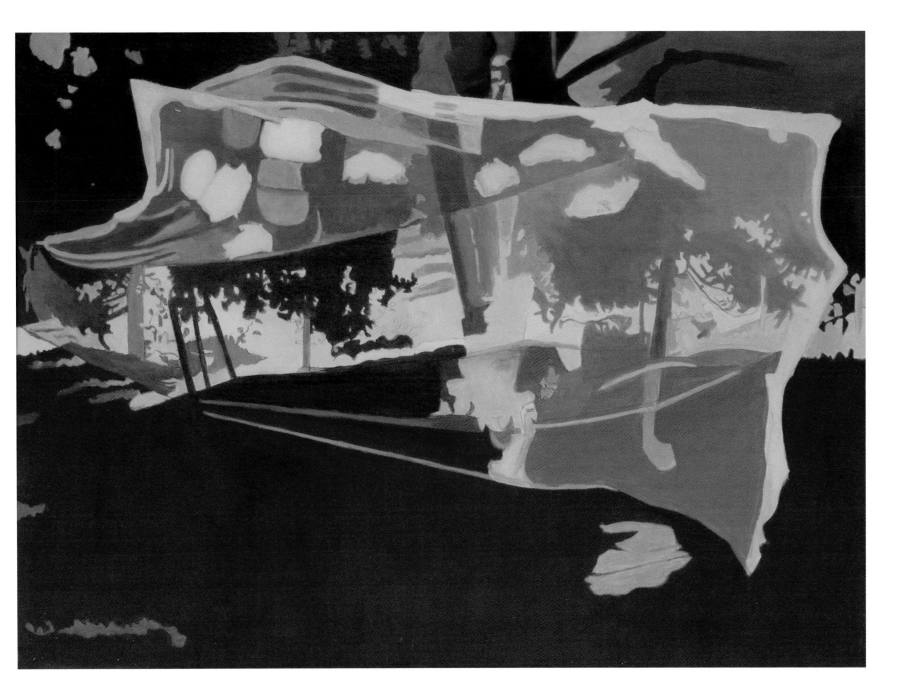

FLURRIES, 1996, OIL ON LINEN, 36" X 50"

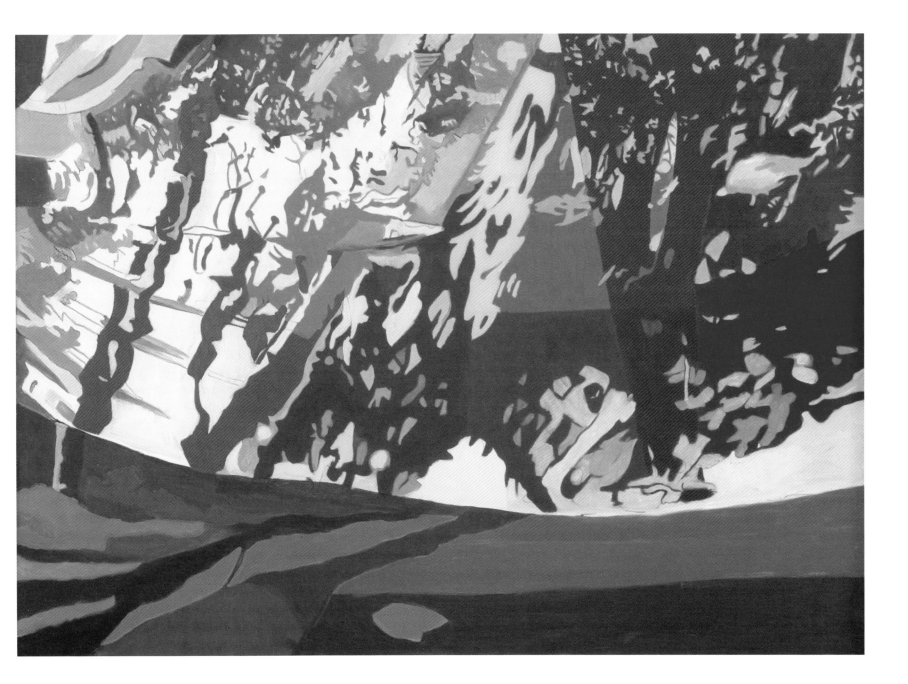

SHADOWS ON THE GRASS 1996-1998

Ralph was always looking for new subject matter with his camera. It was only natural for him to look down because in photographing the Vredenburg stream this is the way that he looked at the pools of water. At some point in the mid-90s, I noticed that he had taken photographs of the sidewalk outside the house. Later, he painted one painting of the sidewalk. Probably, because it was an inanimate object, he quickly moved on to photographing the shadows of the trees on the grass. At that point, I realized that all of nature is abstract. It just depends how you look at it and what is really there.

Walter Wickiser
New York, 2013

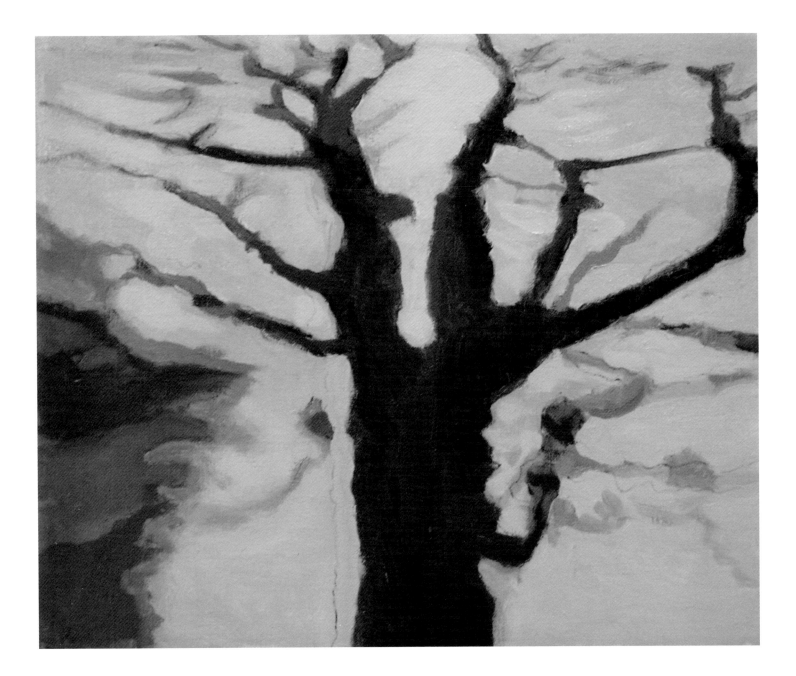

LITTLE TREE, 1998, OIL ON LINEN, 8" X 10"

EDGE OF THE FOREST, 1998, OIL ON LINEN, 8" x 12"

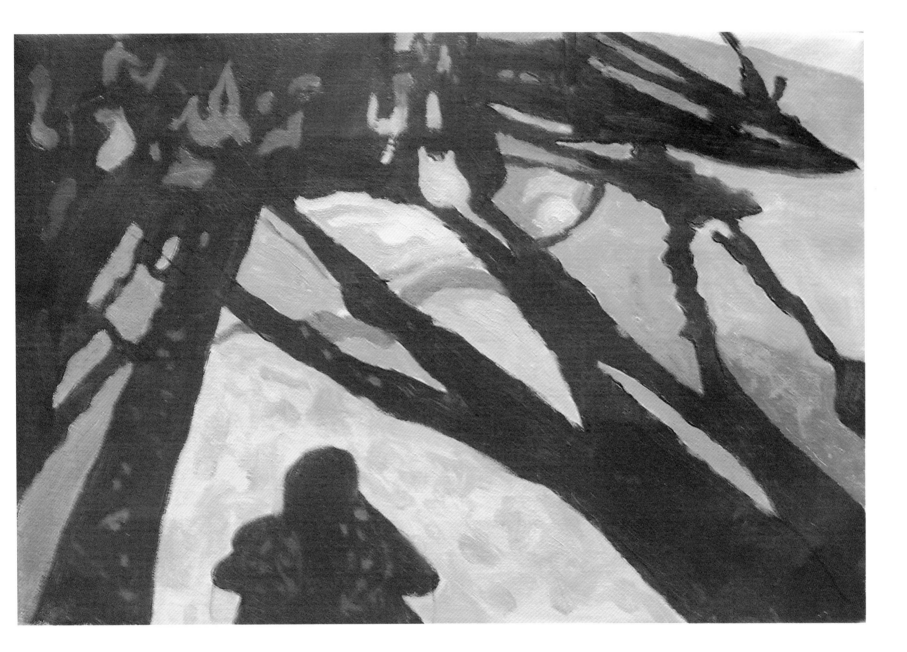

GREEN LAWN, 1997, OIL ON LINEN, 26" x 34"

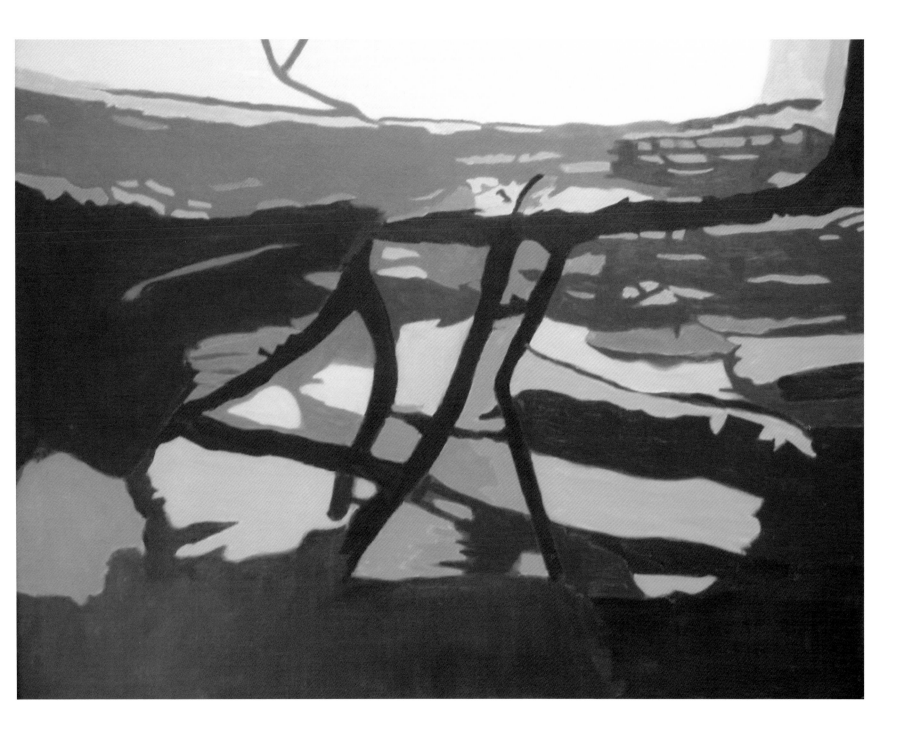

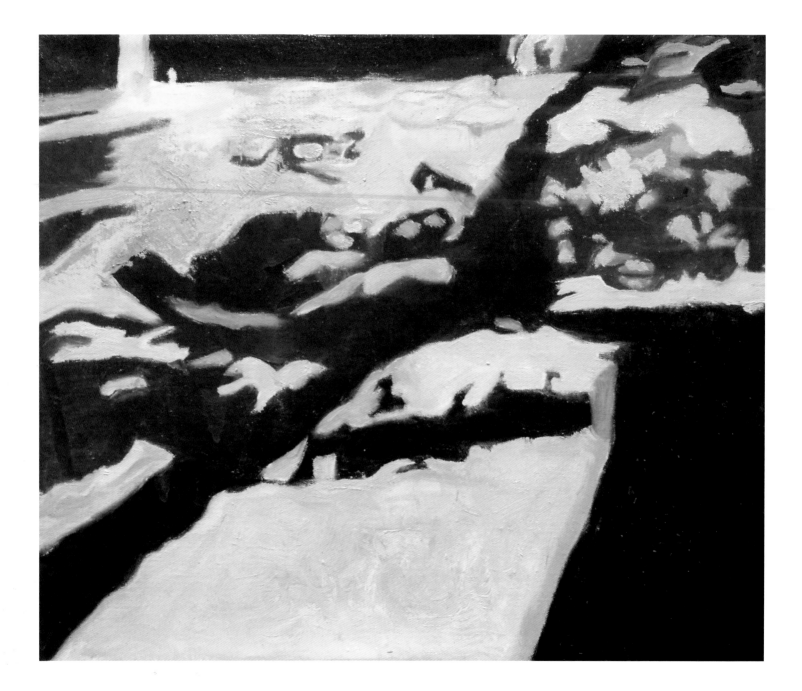

SHADOWS, 1996, OIL ON LINEN, 10" x 12"

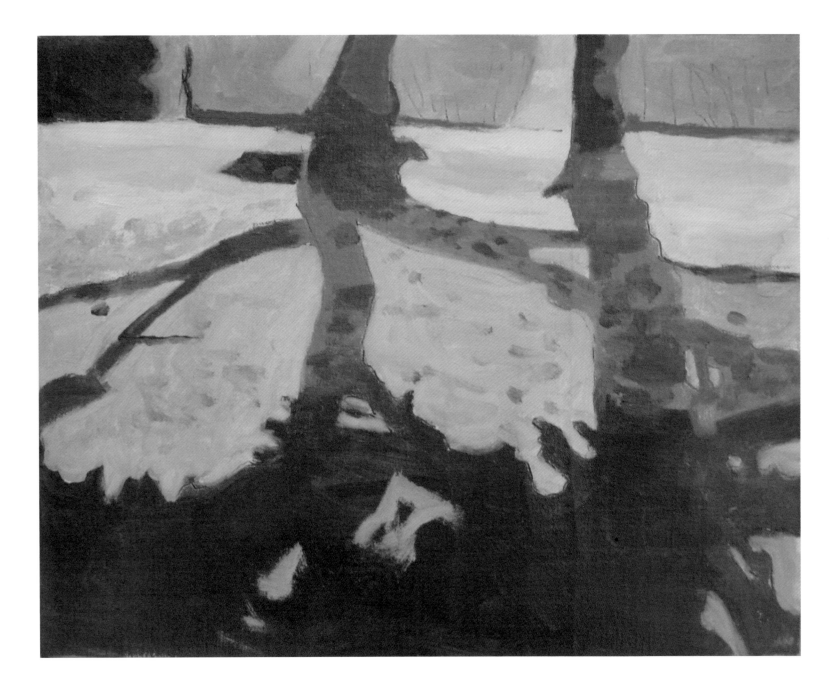

THE PATH, 1998, OIL ON LINEN, 8" x 10"

SHADOWS ON THE GRASS, 1997, OIL ON LINEN, 26" X 36"

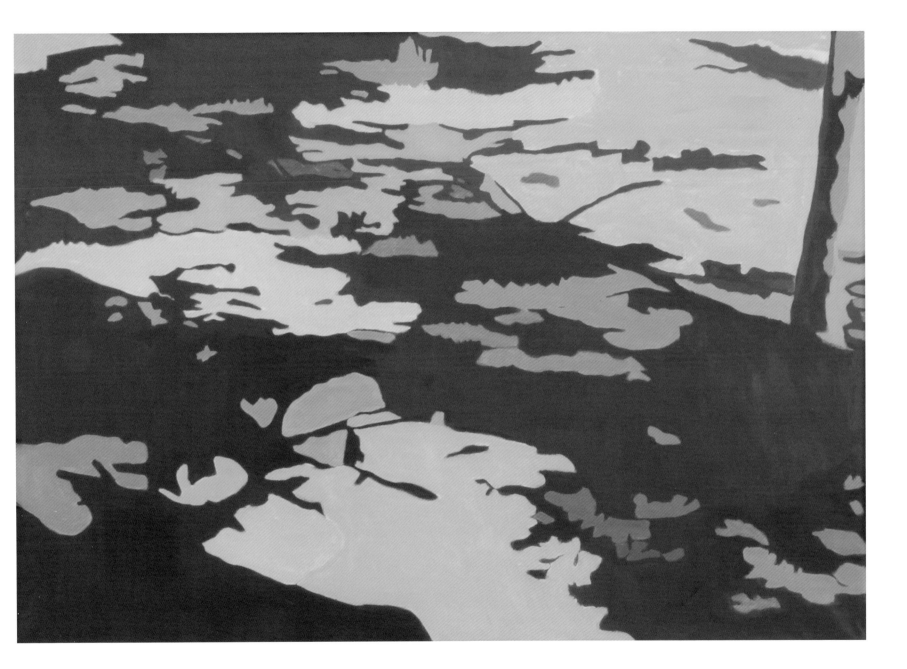

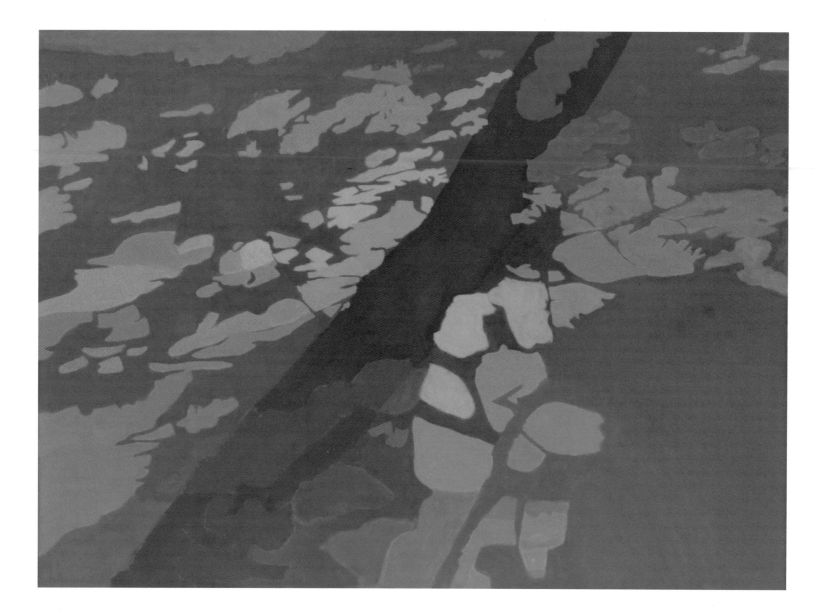

THE WINDING STRIPE, 1998, OIL ON LINEN, 36" X 50"

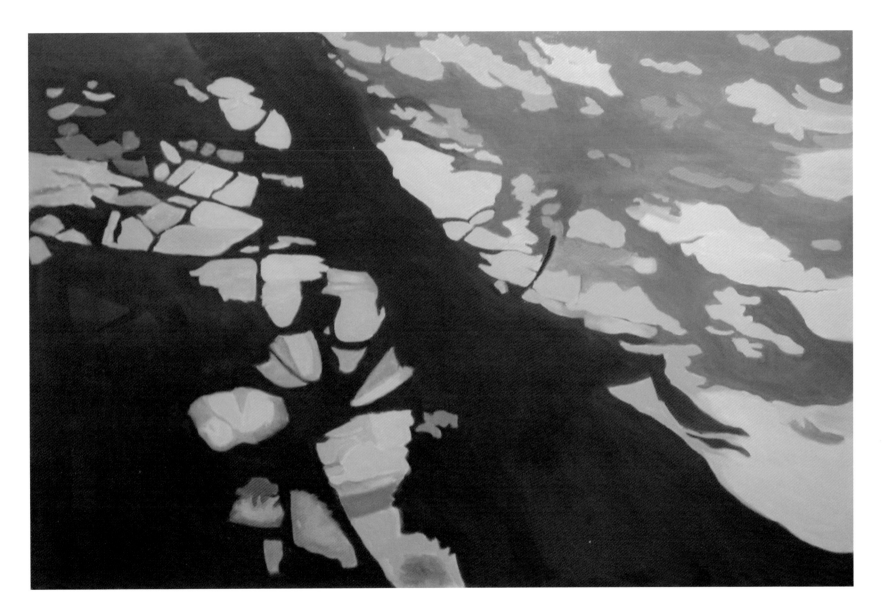

PURPLE STRIPE, 1998, OIL ON LINEN, 26" x 40"

FRONT LAWN, 1997, OIL ON LINEN, 26" x 34"

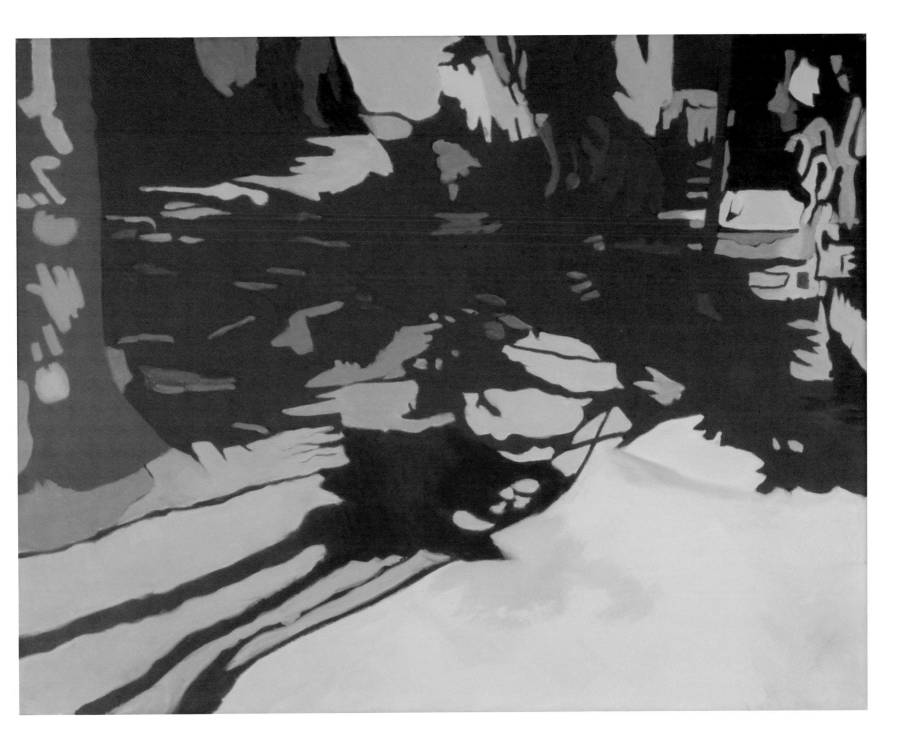

SELECTED BIBLIOGRAPHY

PERIODICALS

1934 "Tiffany Artists Are Now on View at Grand Central". *ARTnews,* October 27, 1934.

Devree, Howard. "In the Galleries: Rowlandson to Fledglings". *The New York Times.*

1936 "In One-Man Exhibit Here". *The Nashville Tennessean,* May 16, 1936.

Cole, Frances. "Wickiser Exhibit at Studio Club Show Wide Variety". Nashville, TN.

"Symposium in Fine Arts to Be Held". Baton Rouge, LA: *The Reveille,* July 24, 1936.

"Tennessee Paintings, Ten by Nashvillians, on Way to N.Y. Show". Nashville, TN.

1937 "Club Speaker Says America Must Have Own Expressive Art". Marfeesboro, TN: *Women's Features-Society,* January 2, 1937.

1939 "Girl in A Doorway by Ralph Wickiser". *The Times-Picayune New Orleans States,* November 12, 1939.

Amrine, Mike. "N.O. Is Reaching Maturity In Art As 8 Shows Open in 3 Galleries". December 3, 1939.

1940 Jenkins, Jerry. "Works of Wickiser Shown in Exhibition". May 15, 1940.

"Wickiser's Etching to be Shown Sunday". Canton, NY, May 22, 1940.

1941 "'Girl at Mirror' in the Making". February 22, 1941.

"Wickiser Show". Baton Rouge, LA: *Morning Advocate,* March 30, 1941.

"L.S.U. Artists to Exhibit Work at Three Shows". Baton Rouge, LA, April 13, 1941.

"Two Little Theaters Plan 1941 Season - L.S.U Shows Have Variety". Baton Rouge, LA, September 14,1941.

"Wickiser Named New Art Head at University". Baton Rouge, LA: *Morning Advocate,* September 14, 1941.

"Two Positions Filled on L.S.U Faculty". New Orleans, LA: *The Times-Picayune,* September 15, 1941.

"Dr. R. Wickiser Heads University Art Department". Baton Rouge, LA: *State Times,* September 15, 1941.

"Chairman". New Orleans, LA: *The Times-Picayune,* September 15, 1941.

"Southern Group Members to Be on Hand for Opening of Art Exhibit at L.S.U. Today". Baton Rouge, LA, October 12, 1941.

"Southern Group Opens Exhibit", October 14, 1941.

"Dr. Wickiser, Lecturer Art League Exhibition". New Orleans, LA: *The Times-Picayune,* October 16, 1941.

"Southern Group Will Meet As New Art Exhibit Opens". New Orleans, LA: *The Times-Picayune,* October 19, 1941.

"L.S.U. Art Classes to Be Open for Visitors; Southern Exhibit Up". Baton Rouge, LA: *Morning Advocate.*

"40 Local Artists Are Included in Show of Art Commission". Baton Rouge, LA: *Morning Advocate.*

"Wickiser Exhibit at Southwestern". Baton Rouge, LA: *Morning Advocate.*

1942 "Wickiser Painting to Continue Tour". New Orleans, LA: *The Times-Picayune,* February 22, 1942.

"Wickiser Paints with Prolific Brush". Baton Rouge, LA: *The Summer Reveille,* August 18,1942.

1943 Darling, W. M. "Pen, Chisel and Brush". New Orleans, LA: *The Times-Picayune,* March 14, 1943.

1946 "Wickiser's Lithograph Takes High Award in the Fifth Annual Louisiana Artists Show Here". Baton Rouge, LA: *State-Times,* May 14, 1946.

"Orleans Artists Show Best Work". New Orleans, LA: *The Times-Picayune,* May 15, 1946.

"Halloween Fun". Baton Rouge, LA: *State Times,* October 30, 1946.

Browne, Vivian. "Six Southern Artists to Exhibit at UC's Annual Show on Nov. 17". *The Chattanooga Times,* November 10, 1946.

1947 Harrell. "Mardi Gras Day Illustrated by Durieux, Wickiser, and McCrady". Baton Rouge, LA: *Morning Advocate.*

"The American Highway- Lithography by Ralph L. Wickiser". New York, NY: Standard Oil Company (New Jersey), 14-18, June, 1947.

1948 "Mardi Gras Gayety Fills Joyous Book". *Chicago Sunday Tribune.*

Tallant. "Mardi Gras in Pen, Brush". New Orleans, LA: *The Times-Picayune,* January, 1948.

"Jokes on the Joker". *Times-Picayune New Orleans State Magazine,* 20-21, February 8, 1948.

Wedeck, Harry E. "New Orleans Carnival". *The New York Times,* February 8, 1948.

Giloin, Aida Mumford. "Louisiana Trapper Paintings by Ralph Wickiser". Dearborn, MI: *Ford Times,* 42, February 1948.

1950 Shane, George. "Delta Artists Draw From Local Scenes". *Des Moines Sunday Register,* 1, 12, July 9, 1950.

1951 "Wickiser, W.A.A. Chairman Praises Artists' Activities". Kingston, NY: *News Leader,* September 7, 1951.

"Gift to Art Commission". Baton Rouge, LA: *Morning Advocate*, November 19, 1951.

"Presented to Art Commission". Baton Rouge, LA: *State Times*, November, 1951.

1952 Frankfurter, Alfred. "In the Painters' Own Words". A Book Review of The Art of the Artist, *The New York Times*, January 27, 1952.

Bier, Justin. "Wickiser Work". Louisville, KY: *The Courier-Journal*, 5, 4, March 23, 1952.

1953 Rivers, Bill. "Ph.D. With a Palette". Baton Rouge, LA: *Morning Advocate Magazine*, November 29, 1953.

1954 "Art Association Opens Annual Jury Show". *Riders' Digest*, 7, March 22, 1954.

Wickiser, Ralph. "Tradition Is Guide Post to Past; Problem Is to Get Closer to Life". Woodstock, NY: *Woodstock Press*, 5, September 9, 1954.

1955 Wickiser, Ralph. "A Contemporary Painters Attitude Toward Tradition". *College Art Journal XIV*, Spring 1955.

1958 "An Introduction to Art Education". *School Arts: The Art Education Magazine*, February, 1958.

1959 "Chairman of Art Education At Pratt Institute". Greenup, IL: *Greenup Press*, August 20, 1959.

1965 "Wickiser Named as Chairman of Graduate Programs". Pratt Institute, Brooklyn, NY: *Prattler* , May 14, 1965.

1966 Bartczak, Peter. "Wickiser: The Work and the Man". Brooklyn, NY: *Prattler*.

1968 "Pratt Director Has Exhibit At Eastern Illinois University". *New York and Brooklyn Daily*, January 24, 1968.

"Wickiser Exhibition at Eastern Illinois University"

1976 "Ralph Wickiser - Lotus". *The Village Voice*, April 19, 1976.

"ART: Wickiser - Lotus Gallery". *The New York Times*, April 24, 1976.

1977 "The Woodstock Landscape". *Woodstock Times*, December 8, 1977.

1982 Combs, Tram. "Wickiser's Common Glories". *Woodstock Times*, 12. November 18, 1982.

"Ralph Wickiser: New Look in Landscape Painting". *Woodstock Times*, November 18, 1982.

1983 "Art Notes: WAA Membership Meeting". May 26, 1983.

Isaacs, Lei. "Wickiser Art UCCA Gallery". *Woodstock Times*, October 13, 1983.

"UCCA Juried Exhibition Opens New Gallery". *Woodstock Times*, December 15, 1983.

1984 "Alice Baber Estate Gives Paintings to Tarble Center". Charleston, IL: *Mid-Illinois Newspapers*, February 1, 1984.

1987 "Dialogues at WAA". *Woodstock Times*, June 18, 1987.

1990 George, Jean Craighead. "Woodstock's Wickiser Featured in Two Shows". Kingston, NY: *Sunday Freeman*, 7, December 23, 1990.

"Wickiser In the City". *Woodstock Times*, 20, December 20, 1990.

1991 Wise, Tad. "Pieces of Eight". *Woodstock Times*, August, 1991.

1992 Twine, Tinker. "Natural Man: Artist Limns Rock and Stream with Easy Grace". *Woodstock Times*, September 17, 1992.

Shine, James G. "Park West Exhibit Shows First-Class Collection". Kingston , NY: *Daily Freeman*, October 30, 1992.

1993 Shine, James G. "The Artists' Lovely World of Landscapes". Kingston, NY: *Daily Freeman*, May 28, 1993.

Shine, James G. "Gallery at Park West - The First Two Years". Kingston, NY: *The Kingston Freeman*, February 26, 1993.

"Meditations". New York, NY: *The Villager*, April 21, 1993.

1994 Raynor, Vivien. "Contemporary Variations on a Timeless Hudson Valley Theme". *The New York Times*, July 24, 1994.

1995 Nakayama, Mikiko. "Ralph Wickiser: Nature is the Most Beautiful". *New York Magazine*, 26, August, 1995.

1996 "New York Art Scene: Ralph Wickiser". Tokyo, Japan: *Asahi Art Pictorial*, 7, February, 1996.

1996-97 Sumiko, Kaneko. Tokyo, Japan: *Art Vision*, Winter, 24-2, 76, 1996-1997.

1997 Gladstone, Valerie. "Ralph Wickiser". *ARTnews*, 166, October, 1997.

"Art Center Features Landscape Works, McEwan and Wickiser Paintings 'Massive'". Parkersburg, WV: *The Parkersburg Sentinel*, 9, July 21, 1997.

Muller, Seth. "Study in Contrasts, Summer Exhibit Merges Realism, Abstract Art".

Bace, Bill. "Visual Culture's Living Treasures". New York, NY: *Review*, 3, May 1, 1997.

1999 Henry, Gerrit. "The Four Seasons". *Art in America*, December, 1999.

2003 Cleveland, David. "Reviews: The Reflected Stream, The Early Years 1975-1985 ". *ARTnews*, October, 2003.

2006 "Lani Tupu." Farscape.com, June 2006. Accessed January 2012: http://www.watchfarscape.com/index.php?option=com_content&task=view&id=194&Itemid=2.

2007 Arbogast, Joanne. "Lore Degenstein Gallery Presents Ralph Wickiser Exhibition". Selinsgrove, PA: *The Daily Item*, 4, November 8, 2007.

 Kidd, Victoria. "Lore Degenstein Gallery Presents Ralph Wickiser Exhibition." susqu.edu, Susquehanna University, November, 2007. Accessed January 2012: http://www.susqu.edu/news/16657.asp.

2009 Greben, Deidre S., "Ralph L. Wickiser." New York, NY: *ARTnews*, June, 2009, p. 107.

2012 "Ralph L. Wickiser, One Of The Artists Presented By Walter Wickiser Gallery At Art Chicago, 2011." mapanare.com, May, 2011. Accessed January 2012: http://www.mapanare.us/10/post/2011/5/ralph-l-wickiser-presented-by-walter-wickiser-gallery.html.

 "Ralph L Wickiser." The Arteur: thestarryeye network. Accessed January 2012: http://thestarryeye.typepad.com/art/2011/07/ralph-l-wickiser.html.

 "Ralph Wickiser." Art in Embassies; US Department of State. Accessed January 2012: http://art.state.gov/ArtistDetail.aspx?id=164064.

 Rodeiro, Jose. "Bio." Jose Rodeiro Art; rodeiro-art.com. Accessed January 2012: http://rodeiro-art.com/index.php?option=com_content&view=article&id=2&Itemid=2.

 "Art Toronto 2012" Dilettante's Diary. Accessed October 2012: http://www.dilettantesdiary.com/id215.html

Books and Catalogs

1952 Hunter, E. R. *Seventh Southeastern Annual Exhibition*. Exhibition Catalog. September 28- October 12, 1952, Atlanta, GA: High Museum of Art, Atlanta Art Associations.

1953 *Annual Exhibitions of Contemporary American Painting* October 15 -December 6, 1953, New York, NY: Whitney Museum of American Art.

1961 *The Author and Writers Who's Who*. London, England.

1962-63 *Dictionary of International Biography*. London, England.

1968 Watkins, Benjamin. *A Retrospective Exhibition of Paintings* Exhibition Catalog. January 7 - February 8, 1968, Charleston, IL: Paul T. Sargent Gallery, Eastern Illinois University,

1970 *The Dictionary of British and American Writers*. London, England.

1970-71 *Who's Who in America*. Chicago, IL: Marquis.

1971 *Directory of Education Specialist. Baltimore*, MD, Spring 1971.

 The Author and Writers Who's Who. London, England.

 The Blue Book: Leaders of the English Speaking World. London, England: *St. James Press*.

1972 *Who's Who in the United States*.

 The Blue Book: Leaders of the English Speaking World. London, England: *St. James Press*.

1972-73 *The National Register of Prominent Americans & International, Notables*. Venice, FL: *Research Center*.

1973 *Dictionary of International Biography New York Art Year Book*.

 Who's Who in American Art. New York, NY: *Bowker*.

 The Blue Book: Leaders of the English Speaking World. London, England: *St. James Press*.

1973-75 *Who's Who*. New York, NY: *USPRS*.

 Who's Who in the East. Boston, MA: *Roosevelt & Larkin*.

 Who's Who in Art. Trade Press.

 The Writer's Directory. New York, NY: *St. Martin's Press*.

1974 *Dictionary of International Biography*. London, England.

1975 *Who's Who in the United States*.

1975-76 *New York Art Year Book*.

1978 *The Blue Book: Leaders of the English Speaking World*. London, England: *St. James Press*.

1979 *The Blue Book: Leaders of the English Speaking World*. London, England: *St. James Press*.

1981 *Who's Who in American Art*. Jaques Cattell Press.

1983 *Who's Who in America*. Chicago, IL: *Marquis*.

1988 Krantz, Les. *The New York Art Review*. Chicago, IL: *American References Publishing*, 1272, 1274, 1288.

1991 Combs, Tram. *Ralph Wickiser*. Exhibition Catalog, November 16 - December 6, 1991, New York, NY: Z Gallery.

1993 *Five Artists Haenah-Kent Group Exhibition Catalog*. Exhibition Catalog. September 18 - October 13, 1993, New York, NY: Haenah-Kent Gallery.

1994 Combs, Tram. *Ralph Wickiser, The Reflected Stream and the Covered Apple Tree, Paintings 1978 - 1993*. Exhibition Catalog, New York, NY: Walter Wickiser Gallery, Inc., April, 1994.

1996 Wei, Lilly. *Ralph Wickiser, The Compassion Series, Paintings 1950 - 1956*. Exhibition Catalog. New York, NY: Walter Wickiser Gallery, Inc., January, 1996.

1997 Tully, Judd. *Purple Rocks & Then Some: Recent Abstract Landscape Paintings of Ralph Wickiser. Ralph Wickiser, The Reflected Stream 1996 - 1997*. Exhibition Catalog. New York, NY: Walter Wickiser Gallery, Inc., April, 1997.

 Zevitas, Steven. *New American Paintings, NYC Artists*. Wellesley, MA: Open Studio Press, 108-109, 127, June, 1997.

2000 Tortora, Lydia. *Ralph Wickiser, The Four Seasons, Works From the 1970's*. Exhibition Catalog. New York, NY: Walter Wickiser Gallery, Inc., April, 2000.

 Wickiser, Jane. *Ralph Wickiser, The Covered Apple Tree 1987 - 1998*. Exhibition Catalog, New York, NY: Walter Wickiser Gallery, Inc., April, 2000.

2003 Henry, Gerrit. *The Reflected Stream, The Early Years 1975-1985*. New York, NY: Walter Wickiser Gallery, Inc. October, 2003.

2009 Cleveland, David. *The Reflected Stream, The Early Years 1975-1985*. New York, NY: Walter Wickiser Gallery, Inc., February, 2009.

2010 Cleveland, David A., *A History of American Tonalism: 1880-1920*. New York, NY: Hudson Hills Press: 2010.

 Dean, Kevin. *REAL(ists)*. Sarasota, FL: Selby Gallery, Ringling College of Art and Design, 2010.

2012 Cleveland, David. *The Reflected Stream, The Abstract Years 1985-1998*. New York, NY: Walter Wickiser Gallery, Inc., April, 2012.

2013 Tortora, Lydia Wickiser/Wickiser, Walter. *The Covered Apple Tree 1987-1998 and Shadows on The Grass 1996-1998*. New York, NY: Walter Wickiser Gallery, Inc., April, 2013.

AUTHOR OF THE FOLLOWING BOOKS

1946 *Encyclopedia of the Arts*. (Contributing Editor)

1947 *An Introduction To Art Activities*. NY: Henry Holt and Company, Inc.

1948 *Mardi Gras Day*. with Caroline Durieux; John McCrady, NY: Henry Holt and Company,Inc.

1957 *An Introduction to Art Education*. NY: World Book Company.

VIDEO DOCUMENTARIES & TELEVISION APPEARENCES

1991 *"Five Artists Show"* at Pratt Manhattan Center, Puck Building, Soho, NY, Produced by Bill Page, Images Art, New York, Manhattan and Paragon Television

1992 *"Ralph Wickiser"*, Produced by Bill Page, Images Art, New York, Manhattan and Paragon Television

LECTURES

1946 Chattanooga Art Association

1949 Vassar College, Woodstock Art Conference - Moderator

1950 University of Florida

1951 Bard College, Conference on Art in the Liberal Arts College
New York Public Library, "In Search of the Muse"
College Art Association, "The Artist as Teacher"

1952 Michigan State University, Graduate Seminar on Art Education
Michigan Art Education Association "Art and Value"
Fourth Annual Woodstock Art Conference, "Aesthetics and the Artist"

1953 American Council of Learned Societies Conference
on Art and Art Education, Washington, DC

1954 Dallas Art Education Association

1955 Stephen Austin College

1957 SUNY Potsdam, Spring Festival of the Arts

1961,63 Patterson State College

1962 New Jersey Art Education Association, Atlantic City

1963 University of Minnesota
St. Joseph's Women's College, Brooklyn, New York

1977 University of Florida at Tampa

SELECTED SOLO EXHIBITIONS

1935	Centennial Club, Nashville, TN		The Gallery at the Roundabout Theatre, New York, NY
1936	Louisiana State University, LA	1998	Walter Wickiser Gallery, Inc., Soho, NY
	Studio Club, Nashville, TN	1999	*"The Four Seasons"* Walter Wickiser Gallery, Inc., Soho, NY

1935 Centennial Club, Nashville, TN

1936 Louisiana State University, LA

Studio Club, Nashville, TN

1939 Gresham Gallery, New Orleans, LA

1940 Drury College, MI

1941 Southwestern University, Lafayette, LA

1943 Delgado Museum of Art, New Orleans, LA

1952 University of Louisville, NY

1954 Louisiana State University, LA

1968 *"Retrospective"*, Eastern Illinois University, Charleston, IL

1974 Harriman College, Harriman, NY

1975 Pacem en Terris Gallery, United Nations, NY

1976 Lotus Gallery, NY

1978 Harriman College, Harriman, NY

Lotus Gallery, NY

1982 Esta Robinson Gallery, NY

1990 Gallery 630 B, New Orleans, LA

1991 Z Gallery, Soho, NY

1992 Park West Gallery, Kingston, NY

1993 Walter Wickiser Gallery, Inc., Soho, NY

1994 *"The Reflected Stream and the Covered Apple Tree"* Walter Wickiser Gallery, Inc., Soho, NY

1995 Walter Wickiser Gallery, Inc., Soho, NY

1996 *"The Compassion Series, 1950-1956"*, Walter Wickiser Gallery, Inc., Soho, NY

1997 *"Purple Rocks & Then Some, The Reflected Stream 1996-1997"* Walter Wickiser Gallery, Inc., Soho, NY

Parkersburg Art Center, Parkersburg, WV

The Gallery at the Roundabout Theatre, New York, NY

1998 Walter Wickiser Gallery, Inc., Soho, NY

1999 *"The Four Seasons"* Walter Wickiser Gallery, Inc., Soho, NY
Saginaw Art Museum, Saginaw, MI

2000 *"The Covered Apple Tree Series"*, Walter Wickiser Gallery, Inc., Soho, NY

2002 *"The Reflected Stream"*, Walter Wickiser Gallery, Inc., Soho, NY

2003 Thomas Cole House, Hudson, NY

"The Reflected Stream, The Early Years 1975 - 1985", Walter Wickiser Gallery, Inc., Soho, NY

2004 *"The Compassion Series, Abstract Paintings of the 1950s and the 1960s"*, Walter Wickiser Gallery, Inc., Soho, NY

2005 *"The Reflected Stream, The Abstract Years, 1985-1998"* Walter Wickiser Gallery, Inc., Soho, NY

2006 *"The Reflected Stream, The Early Years, 1975-1978"*, Walter Wickiser Gallery, Inc., Chelsea, NY

2007 *"Ralph Wickiser a Retrospective 1934-1998"* Susquehanna University, Selinsgrove, PA

"Ralph L. Wickiser Paintings, 1957-1975, The Compassion Series - The Late Abstractions, 1957-1965, Vanity, Irene and the Apple, The Nude Series 1969-1975", Walter Wickiser Gallery, Inc., Chelsea, NY

2008 *"Shadows On The Grass 1996-1998"* & *"The Covered Apple Tree 1987-1998"*, Walter Wickiser Gallery, Inc., Chelsea, NY

2009 *"Ralph Wickiser: A Retrospective 1934-1998"* Adelphi University, Long Island, NY

"Ralph Wickiser: A Retrospective 1934-1998", Walter Wickiser Gallery, Inc., Chelsea, NY

2010 *"Ralph Wickiser: The Four Seasons"*, Walter Wickiser Gallery, Inc., Chelsea, NY

2011 *"Ralph Wickiser: A Retrospective of the Reflected Stream: 1975-1998"*, Walter Wickiser Gallery, Inc., Chelsea, NY

2012 *"Ralph Wickiser: The Lydia Tortora Collection"*, Walter Wickiser Gallery, Inc., Chelsea, NY

2013 *"Ralph Wickiser: The Covered Apple Tree 1987-1998 and Shadows on The Grass 1996-1998"*, Walter Wickiser Gallery, Inc., Chelsea, NY

SELECTED GROUP EXHIBITIONS

1934	Grand Central Galleries, New York, NY Studio Club, Nashville, TN	1954-56	State Department. European Traveling Exhibition of Color Lithographs
1936	Rockefeller Center, New York, NY	1956	State University of New York, New Paltz, NY
1937	Studio Club, Nashville, TN	1957	Woodstock Artists Association, NY
1937-41	"A New Southern Group", Traveling Exhibition, USA	1959	Brooklyn Museum, Brooklyn, NY Long Island University, Long Island, NY Momentum Institute of Design, Chicago, IL Woodstock Artists Association, NY
1938	Friends of Art, Baltimore, MD Third National Exhibition of American Art and Fine Arts Society, NY Harrisburg Art Association, PA		
1939	Detroit Institute of Fine Arts, MI	1960	YMHA New York, NY Woodstock Artists Association, NY Pratt Institute, Brooklyn, NY
1941	Northeast Junior College, Louisiana, LA University of Minnesota, MN	1961	Woodstock Artists Association, NY
1942	Corcoran Gallery, Washington, DC The Print Club, Philadelphia, PA San Francisco Museum, CA Oakland Museum, CA University of Mississippi at Oxford, MS	1962	Pratt Institute Faculty Show, Brooklyn, NY
		1963	Woodstock Artists Association, NY
		1964	Pratt Institute Faculty Show, Brooklyn, NY
		1965	Chelsea Art Association, NY
1943	Delgado Museum, New Orleans, LA	1966	Pratt Institute, Brooklyn, NY
1944	Dayton Museum of Art, OH	1967	Princeton Gallery, NJ
1946	Associated American Artists Gallery, NY University of Chattanooga, TN	1968-71	Pratt Institute, Brooklyn, NY
		1969	Woodstock Artists Association, NY
1947	Dallas Museum, TX	1971	Suffolk Museum, Stony Brook, NY
1948	The Washington County Museum of Fine Arts, Hagerstown, ML Library of Congress Annual Print Exhibition, Washington, DC	1972	Lerner - Miraschi Gallery, NY
		1973	Princeton Gallery of Fine Art, NJ
1950	Metropolitan Museum of Art, NY	1974	Cornucopia Gallery, Empire State Plaza, Albany, NY Grace Gallery, Brooklyn, NY
1950	Des Moines Art Center, IA		
1951	Pennsylvania Academy of Art, Philadelphia, PA	1977	Nassau County Community College, Long Island, NY Mickelson Gallery, Washington, DC
1952-58	George Binet Traveling Exhibition of Religious Prints, USA		
1953	Whitney Museum of American Art Annual, New York, NY	1978	"Work Behind the Work", Ulster County Community College, Stone Ridge, NY Princeton Gallery of Fine Art, NJ
1954	Cincinnati Museum, Cincinnati, OH The Contemporaries Gallery, NY		

"29th New England Exhibition of Painting and Sculpture",
Silvermine Gallery, New Canaan, CT

1979 Brooklyn Museum, Brooklyn, NY

1978-80 Center Square Gallery, Albany, NY

Sunne Savage Gallery, Boston, MA

1981 Somerhill Gallery, Durham, NC

1982-83 Woodstock School of Art, Woodstock, NY

1983 Ulster County Art Association, Kingston, NY

Novo Arts, New York, NY

1986-88 Princeton Gallery of Fine Art, NJ

1988-89 Thompson Gallery, New York, NY

1988 *"Former Faculty Centennial Exhibition"*,

Pratt Manhattan Center, Puck Building, Soho, NY

1989 *"Man and His Space"*, The Society of Landscape and Figurative Artists, Lever House, New York, NY

Strauss Gallery, New York, NY

Bell Gallery, Woodstock, NY

1990 Z Gallery, Soho, NY

Schafler Gallery, Pratt Institute, Brooklyn, NY

1991 *"Five Artists"*, Pratt Manhattan Center, Puck Building, Soho, NY

Woodstock Artists Association, NY

1992 Park West Gallery, Kingston, NY

1993 Marguerite Oestreicher Fine Art, New Orleans, LA

"Five Artists", Haenah Kent, Soho, NY

Walter Wickiser Gallery, Inc., Soho, NY

1994 Park West, Kingston, NY

Haenah Kent, Seoul, Korea

1995 Woodstock Artists Association

1997 Tallahassee Museum of Natural History, Tallahassee, FL

Fernbank Museum of Natural History, Atlanta, GA

1998 Woodstock Guild, Woodstock, NY

1999 Gross McCleaf Gallery, Philadelphia, PA

The Cahoon Museum of American Art, Cotuit, MA

"Abstract Expressionism, Expanding the Canon", Gary Snyder Fine Art, Chelsea, NY

2004 Art Miami, FL

2005 Art Miami, FL

Art Chicago, IL

Art Toronto, Canada

2006 Art Miami, FL

Art Toronto, Canada

2010 (REAL)ists, Selby Gallery, Ringling College of Art and Design, Sarasota, FL

Art Chicago, IL

Art Toronto, Canada

Art Miami, FL

2011 Art Chicago, IL

Art Toronto, Canada

2012 Art Palm Beach, FL

ArtHamptons, Bridgehampton, NY

"Earth, Air, Water", The Woodstock Artists Association & Museum, NY

Art Toronto, Canada

2013 Art Palm Beach, FL

AWARDS AND HONORS

1934,39 Louis Comfort Tiffany Fellowship, Oyster Bay, Long Island, NY

1946,48 Louisiana State Research Council Grant, Baton Rouge, LA

1952 Fund for the Advancement of Education Grant

1956 Honorary PhD, Eastern Illinois University, Charleston, IL

1964 Distinguished Alumni Award, Eastern Illinois University, Charleston, IL

1971-75 Harriman College, Member of the Board of Trustees, Harriman, NY

1975 Men of Achievement Award, Melrose Press, Cambridge, UK

1975 Professor Emeritus, Pratt Institute, Brooklyn, NY

SELECTED PRIVATE COLLECTIONS

Mr. Don Ahn, NY
Mr. Richard Allen, NY
Mr. Robert Allen, NY
Ms. Stephanie Arata, NY
Mr. Sei Arimori, Japan
Ms. Martha Armstrong, MA
Mr. William Breger, NY
Mrs. Kiyoko Ohata Brown, NY
Mr. Song Jun Chon, Korea
Mr. David Cleveland, NY
Mr. Morris Cook, NY
Mr. Nemeir Cortas, London
Mrs. Layla Fanucci, CA
Mr. Robert Feur, NY
Mr. & Mrs. Elliot Gruenberg, NY
Mr. Rollins S. Guild, NY
Dr. Lloyd Harris, NY
Mr. Henry Heald, NY
Mr. Fergus Hoke, London
Mrs. Duoling Huang, NY
Mr. Tchah Sup Kim, NY
Mr. & Mrs. Alan Kleiman, NY
Mr. & Mrs. Klingenstein, NY
Mr. & Mrs. Steven G. Lampe, NY
Ms. Kang Ja Lee, Seoul, Korea
Mr. Daniel E. Muallem, CA
Mr. Vincent Naddeo, NY
Mr. Hiro Nozuka, NY
Mrs. Marguerite Oestricher, LA
Mr. & Mrs. Pearlman, NY
Ms. Ayn Rand, NY
Ms. Lina Shamma, London
Mr. & Mrs. Marc Savitt, NY
Mr. & Mrs. Robert Schwagerl, NY
Mr. & Mrs. Jim Stynes, NY
Mr. Peter Ted Surace, NY
Mrs. Kathy Surace-Smith, WA
Mr. Michael Sut, NY
Ms. Bronwin White, LA
Mr. and Mrs. David Worth, NC
Mr. George Zhaozhi Xiong, NY
Ms. Zhang Zhang, Shanghai

COMMISSIONS

1947 Standard Oil of New Jersey, *The American Highway*,
 Ten colored lithographs reproduced in *The Lamp*, 29, 3, June 1947

1948,49 Ford Company, *Ford Times*, Watercolor Series

SELECTED PUBLIC COLLECTIONS

Bulbrite Inc., NJ
Currier Gallery, Manchester, NH
Continental Trust Bank, Fort Worth, TX
Eastern Illinois University, Charleston, IL
High Museum, Atlanta, GA
Louisiana State University, Baton Rouge, LA
Lehigh University, Bethlehem, PA
Louisiana Art Commission, Baton Rouge, LA
Mint Museum, Charlotte, NC
New Orleans Museum of Art, New Orleans, LA
Pratt Institute, Brooklyn, NY
United Cerebral Palsy Association of Westchester County, Inc
Woodstock Historical Society, NY
Woodstock Artists Association and Museum, NY

TEACHING EXPERIENCE

1941-56 Chairman, Art Department, Louisiana State University, Baton Rouge, LA

1956-59 Director, Division of Art Education, State University, New Paltz, NY

1959-62 Chairman, Art Education Department, Pratt Institute, Brooklyn, NY

1962-75 Director, Division of Graduate Programs in Art and Design,
 Pratt Institute, Brooklyn, NY

1972 Acting Dean, School of Art and Design, Pratt Institute, Brooklyn, NY

1975-78 Visiting Professor Emeritus of Graduate Art, Pratt Institute, Brooklyn, NY

EDUCATION

1928-31 Art Institute of Chicago
1931-34 BA, Eastern Illinois College
1934-35 MA, Vanderbilt and Peabody
1935-38 PhD, Peabody

INDEX

CREDITS

Art work photography: John Kleinhans, Woodstock, NY - pages 60, 87

Art work photography: Becket Logan, New York, NY - pages 29, 33, 36, 38, 42, 45, 52, 53, 73, 79, 81,
89, 91, 92, 101, 106, 113, 114, 117

Portrait photography: Patti Ouderkirk, New York, NY - page 23 (Wickiser with Mr. and Mrs. Pace)

Portrait photography: Al Wooley, Baton Rouge, LA - page 14 (Wickiser printing lithographs), page 16